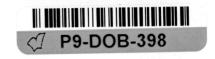

INTERNATIONAL PHOTOGRAPHY

50 years of Leica—half a century of 35-mm photo-
graphy, three generations of photojournalism.
Photographers throughout the world—amateurs and
professionals alike—were invited to participate in
Color Photography Olympiad 1975. The result:
10,204 slides from 2,551 photographers in
54 countries.
A representative selection of 100 outstanding entries
to this international all-round photographic
competition is reproduced with comments on the
following pages. They reflect the high standard of photo
design and the advantages of modern 35-mm
photography.

hotographers

Andersson, Ragnar, 49, Sweden

Balon, Achim, Cover, W. Germany
Becker, Toni, 3, W. Germany
Berg, Kees van den, 63, Holland
Behnke, Julius, 97, W. Germany
Berting, Harald O., 56, USA
Bewley, John W., 44, USA
Biecker, Hans, 80, W. Germany
Bielski, Ben, 48, USA
Blauert, Gunhild, 19, W. Germany
Bluhm, Gerhard, 85, Austria
Boll, Magda, 50, W. Germany
Bottomley, J. A., 8, England
Büttner, Gerhard, 47, W. Germany
de Buhr, Herbert, 43, W. Germany

Chun-Biu Lam, 94, Hong Kong
Clever, Helmut, 41, W. Germany
Conrardy, Jean-Pièrre, 38, Luxembourg

Denecker, Juul, 17, Belgium
Dhara, D. K., 12, India
Dickers, Louis, 84, Belgium
Dünzl, Heribert, 51, W. Germany

Eberwein, Helmar, 54, W. Germany

Fanedel, Norbert, 9, Austria
Folb, Dr. Martin A., 92, USA
Franke, Dr. Klaus, 27, W. Germany
French, Fred W., 4, England

Gehlen, Henri, 78, Luxembourg
Gluske, Paul, 76, W. Germany
Gottschick, Jürgen, 73, W. Germany
Grefen, Reinhard H., 68, W. Germany

Hermann, Helmut, 35, 39, W. Germany
Hermansen, Inge K., 55, Norway
Hoogervorst, Fred, 42, Holland
Ho Pak Kao, 2, 79, Hong Kong

Ingolfsson, Gudmundur, 70, Iceland
Itin, Max, 90, Switzerland
Itter, Wolfgang W., 28, W. Germany

Keßler, Walter, 14, W. Germany
Keup, Jean, 25, Belgium
Kipp, Günther, 62, W. Germany
Klein, Henry, 10, W. Germany
Klemm, Erich, 30, 36, W. Germany
Köhler, Werner, 37, W. Germany
Künkel, Reinhard, 71, 75, W. Germany

Lindman, Svenerik, 86, Sweden
Lindmark, Anders, 66, Sweden
Low Chen Khoon, 81, Malaysia
Lutzelschwab, Paul, 93, France

Mann, Georg, 65, 77, W. Germany
Markefelt, Mark, 99, Sweden
Mayer, Beate, 21, W. Germany
Merfeld, Klaus, 15, W. Germany
Motal, Julius, 64, USA

Neumann, H. Jürgen, 33, W. Germany
Niehuus, Uwe, 57, Holland

Ollmann, Edgar, 7, 20, 87, Austria

Parmentier, H. C., 31, Holland
Paul, Franz, 52, W. Germany
Pauls, Uvo, 40, W. Germany
Pempelfort, Herbert, 23, W. Germany
Petermann, Hannelore, 32, W. Germany
Pötzsch, Johannes, 67, W. Germany
Pötzsch, Thomas, 18, W. Germany
Pruitt, Gil H., 1, USA

Raith, Luitpold, 46, Austria
Reichl, Horst, 11, 91, W. Germany
Reist, Dölf, 6, 82, Switzerland
Riedlhuber, Otmar, 88, Austria
Robin, Klaus, 60, Switzerland
Rüppell, Dr. Georg, 72, W. Germany

Schäfer, Werner, 83, W. Germany
Schultz, Blaine, 98, USA
Seipel, Walter, 53, W. Germany
Spiegel, Walter, 16, 74, W. Germany
Stark, Emilie, 89, W. Germany
Stark, Ewald, 95, W. Germany
Surmont, Remi, 59, Belgium

Tan, L. S., 58, Singapore
Tanzil, O. Hussein, 24, Indonesia
Thiessen, Konstantin, 34, W. Germany

Velte, Werner, 45, W. Germany

Wandelt, Otto, 5, 13, W. Germany
Wandelt, Thomas, 69, W. Germany
Weiß, Herbert H., 96, W. Germany
Wilden, Dr. Bert, 29, W. Germany
Wille, Frank, 61, Denmark
Wyholt, Per, 26, Sweden

Yuen, David W. C., 22, Hong Kong

Living Human Images

Visual perception of a picture, the purely optical impression, is followed by intellectual analysis of the reaction it creates in us. And the more reason there is to assume that the photographer wished to materialize an idea, a clear concept, in his photograph the more likely the picture will appeal to us and produce a real visual experience. Of all the subjects captured by photography, the living human image is probably the only theme with which we are confronted daily — in newspapers and books, and above all on the television screen. There is no need to mention the rock paintings of the Ancient Egyptians to prove that people have enjoyed portraying each other since time immemorial: mother, friend, lover, neighbour, companion. One might cite Mohammed at this point — who forbade his followers to this day to have themselves pictured in any way — to emphasize what importance great leaders have attached to the right to one's own image. (German legislation also states that portraits may only be circulated or put on view to the public with the permission of the person portrayed.) The right to one's image is precious, at times even costly, a right which is even fought for in court. Hardly any other law is broken as frequently as this one.

The work of the amateur and professional photographers who submitted the pictures for this book would suffer badly if they were to adhere strictly to this law. And it seems that, in spite of the burnous and veil, even the Moslems have realised there is no harm in pushing themselves proudly and self-confidently in front of the camera now and then — although not without thrusting a begging hand towards the law-breaker with the camera. The right to one's image is sold for a gratuity. The tourist pays and photographs.

An unusual photographic exhibiton took place in Hanover recently. It caused a stir because the exhibitors had dared to display photos from the private sphere, from the family album. Many a newspaper critic expressed the opinion that this was an original and risky business. Why risky? On display were photos from albums, wallets and handbags, from dilapidated cigar and shoe boxes. Some had been retrieved from a waste paper collection, others were borrowed from museums. Valuable or not, they made a spectacular show. Nothing seemed more amusing and exciting than to peep into the past of one's fellow man, in ageing photos on walls and dressers, photos of our dear ones at christenings, confirmation, weddings, on special occasions and at everyday events. Everybody is familiar with such pictures, there is no need to describe them. If we take them out to look at them, memories stir and the photos from years ago come to life as we ask, "Do you remember?", "Do you recognise me?" Newspapers and magazines published some positive and some ironical reviews on this exhibiton. Yet these photographs, in all their weakness, pride and naivety neither deserve irony nor cynicism, for we would be all the poorer without them. The pictures on the following pages bear no resemblance to the photos in the family album. These are chiefly pictures taken outside the private sphere. They are portraits of people unknown — or hardly known — to the photographer, people he met somewhere in the world as reporter or traveller, people he encountered and photographed.

It is worth considering why the majority of the photographs published here — submitted mainly by

opeans and Americans—are of people from faraway places. It is the foreign and unfamiliar
ect which is particularly interesting. Scenes from the photographer's own life are
arently taboo and seem too unspectacular for a photographic competition. One could draw
clusions as to the sociological behaviour of the photographers. It is significant that Africans and
ans living in simple, even primitive conditions are obviously considered the most rewarding
jects. And the question arises: what is the photographer's attitude towards the content of his
tures? It could be the longing for an unknown paradise on earth which makes him choose such
jects and which expresses itself in the photographic capture of human archetypes.
frontation with people from one's own surroundings—people in highly cicilized countries—
uld on the other hand inevitably lead to introspection and analysis of one's own shortcomings in
earance and personality. Though constantly faced with these inadequecies, we prefer to avoid
m, especially when looking forward to fun and relaxation with the camera. After all, it is a legitimate
h to enjoy photography, particulary for the amateur.
ecent years photojournalism has concentrated on relevant social topics and the negative
ects of human society—hunger, suffering, crime. The result is often embarrassing indiscretion
even pure voyeurism, pictures to which the general public should have no access. Photographers
mmitted to social criticism play a useful and necessary role, above all in photography dealing with
ple, but we must not forget that where there are shadows there is sunshine too. Yet the sunny
e of the street need not be the complete reverse—a satiated, frivolous or amoral life; it can be
y of sunshine that brightens our life. Several of the photographers represented in this book have
empted to capture this in the faces of their subjects. And they have achieved no less—photo-
phically speaking—than the reporter of the periodical of the Kolping Foundation who took the
tressing picture (No. 14) in Mother Teresa's house of death. "People of Today" was the central
me of the competition "50 years of Leica". Participants who hoped to win this competition had to
/ particular attention to the interpretation of this theme. The prizewinning photograph (No. 2) illu-
tes that apart from qualities in technique and composition, the photographer's intellectual achievement
lso decisive. It was clear from the start that with the massive participation of internationally
ious photographers—people with great technical skill—the ability to translate an idea into a
zewinning photo would play a major role in the jury's final decision. The other two obligatory
mes—landscapes and snapshots—offered far more room for interpretation. "People of Today"
s very narrowly defined. Experienced portrait photographers had a hard job to hold their own
inst the live scene. The use of colour made this theme particulrly demanding. It was difficult
ieving the effects in colour that would have been characteristic for August Sander's or
ng Penn's work, full-blooded portraits of impressive figures in black and white. In spite of the
ievements of Ernst Haas, Thomas Höpker, Erwin Fieger and others, human colour photography
till in its infancy. All the more credit for the achievements of the competitors who have produced
our pictures to fit the specified themes that deserve our full admiration.

People of Today

Modern colour photography has been greatly influenced by colour photojournalism as promoted by the world's major illustrated periodicals, in particular by "Life" magazine which unfortunately had to cease publication in 1973. Everything produced by photographers in this field nowadays has to measure up to the work of great "Life" photographers such as Feininger, Brake, Dominis and many others. It is not at all surprising that from all the competition entries to the theme "People of Today", the jury finally selected colourful action scenes. Two of the award-winning photos are published here (Nos. 2 and 3). However, the colour slide of a procession in San Francisco pictured opposite was not placed, although it is a good example of masterly dramatic human portraiture. The reason according to the jury was that it was not framed satisfactorily. Subsequently, during the layout work for this book, a vertical section of the originally horizontal photograph was printed, which resulted in an unusually expressive picture. This serves as an example that increased dynamic effect is achieved by spatial concentration on the content and careful selection of the frame, resulting in more graphic composition and hence optimal clarity of expression both in form and colour. But this selective process must take place through the viewfinder as it is rare that a jury will accept a partly masked slide (as was the case for No. 85).
Dramatic human pictures have their origin in an event, in an occurrence pulsating with action.
The perfection of a composition is often spoiled by irritating objects in the picture which are, however, part of the event itself. The photographer must be able to eliminate these aspects by skillful techniques such as adjusting the depth of field or moving to another position. Only skillful and confident use of the camera and familiarity with all the optical possibilities offered by the various focal lengths enable the photographer to isolate a masterly photo from the confusion of the event (e.g. a mass meeting) in the fraction of a second. One always has to reckon with unforeseen incidents and with sudden changes in the situation. The experienced photographer has to adjust equally fast to the new situation; he reacts intuitively. Seen in this light, photojournalism for the amateur is not just an exciting adventure but useful training in fast reactions and decision-making while working with the camera; a training that cannot fail to lead to success with every demanding subject matter in photography.
Another rewarding aspect of this theme "People" is the non-documentary side. This aspect is increasing in importance as television is taking over the role of topical photojournalism from the magazines. It is difficult to take a good art photo. Unlike documentary photographs, suitable subjects have to be sought. Typical photos in this field are nos. 4—11. A keen eye is a necessity for such pictures which distinguish themselves through their richness in atmosphere, the mood of the event and often their originality. Good photos of this type are in high demand. Sometimes they are enigmatic and—like good cartoons—appeal only to those who can decipher their symbols and analogies.
It is difficult to express humour in a photograph, whether openly or implied; genuine natural scenes photographed with intelligence and wit are a prerequesite for success in this field.

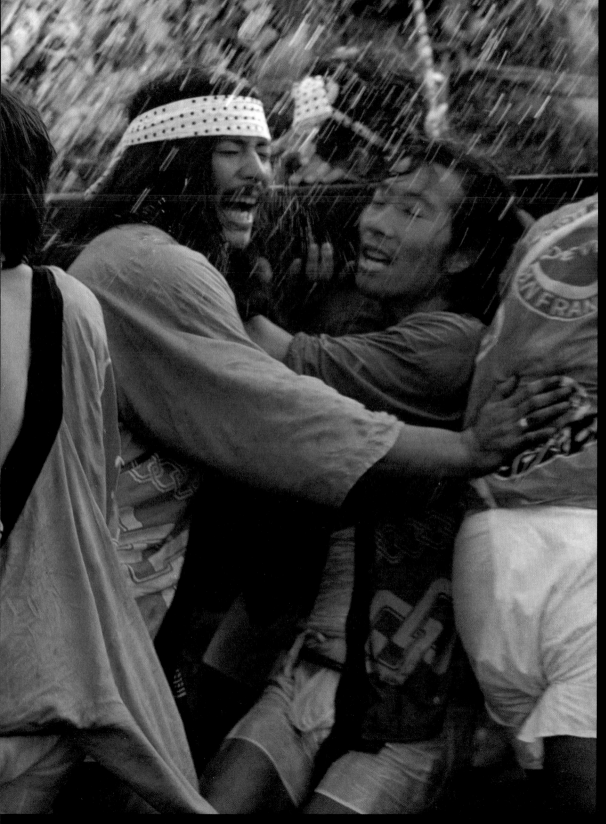

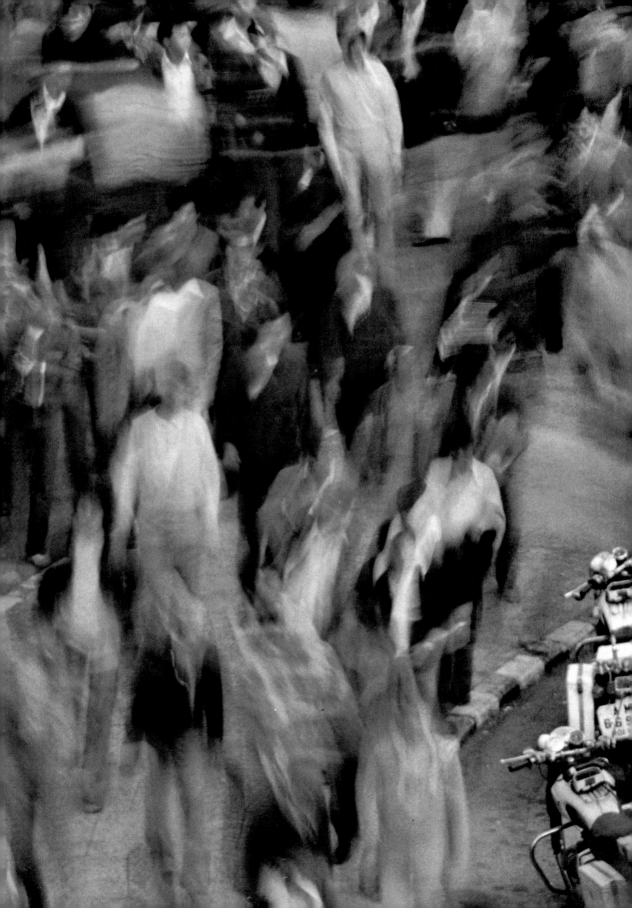

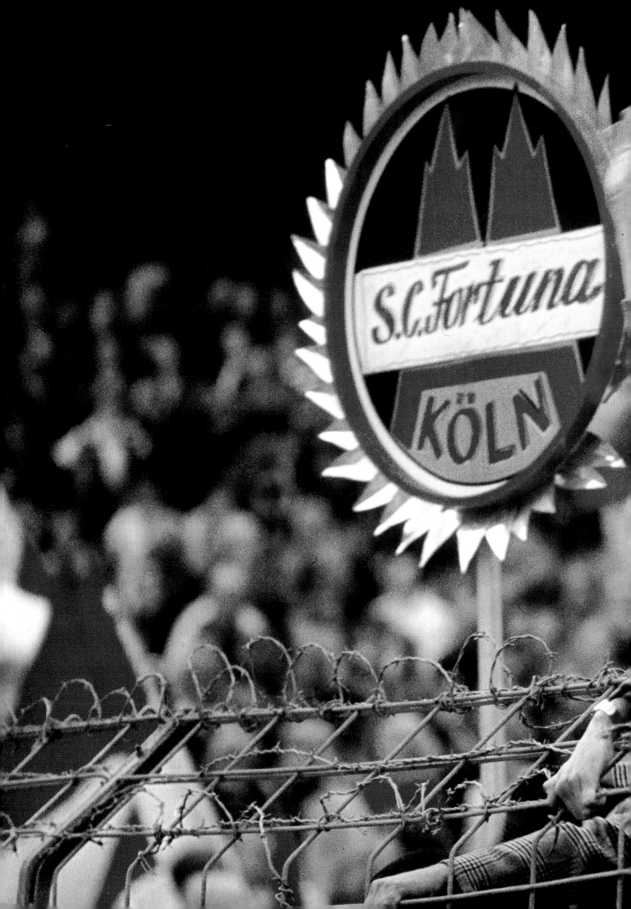

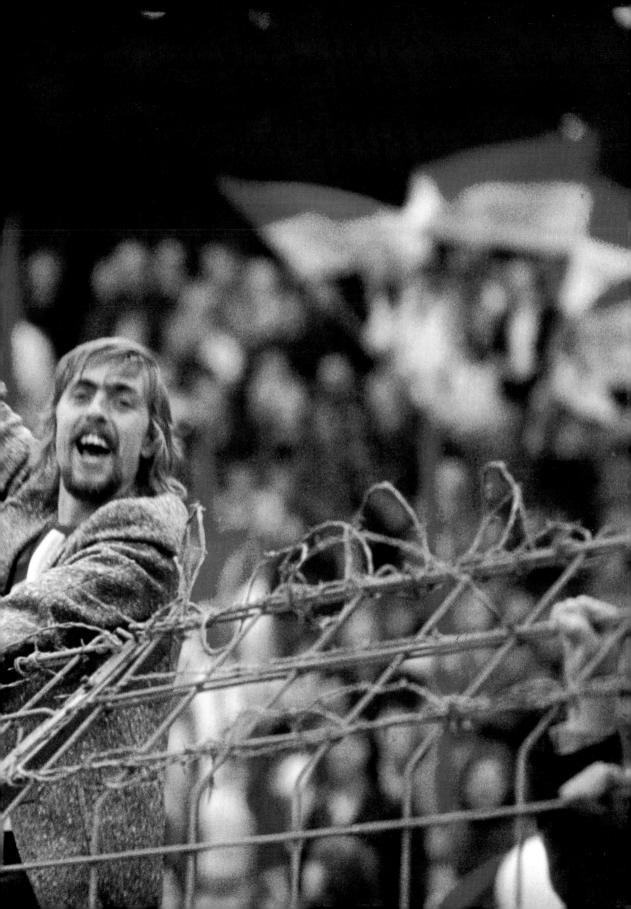

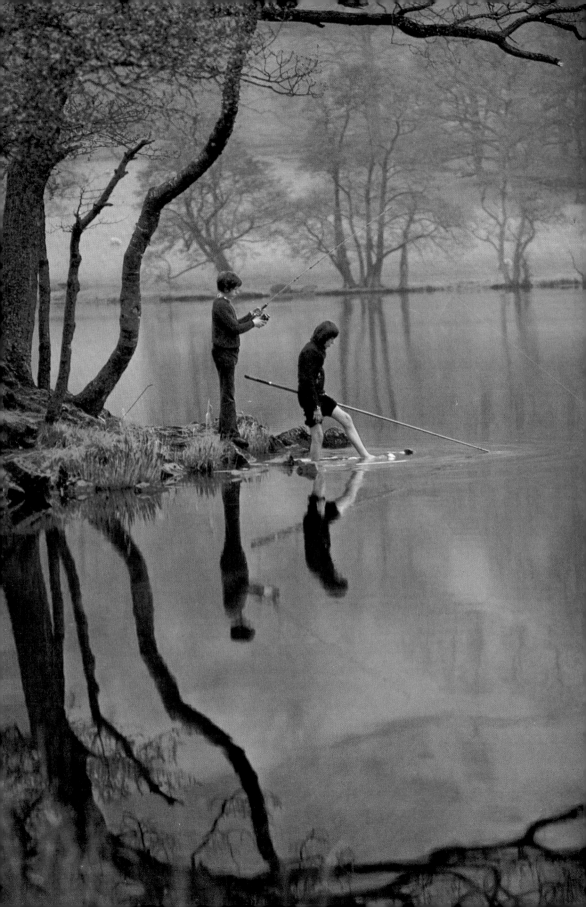

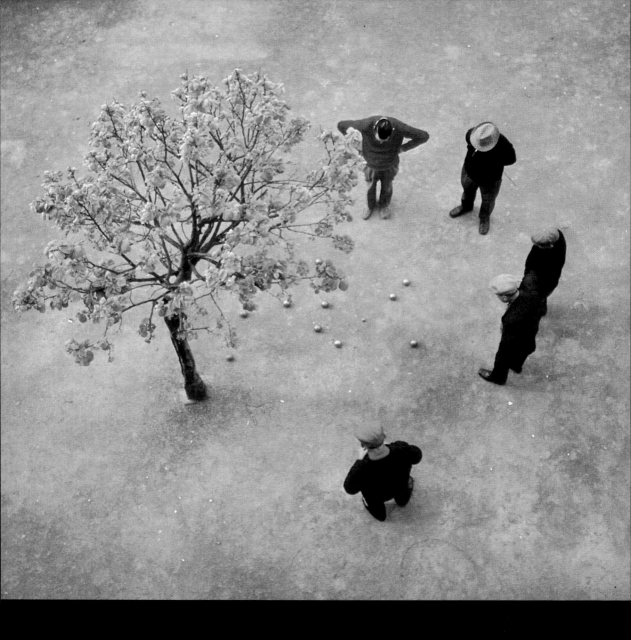

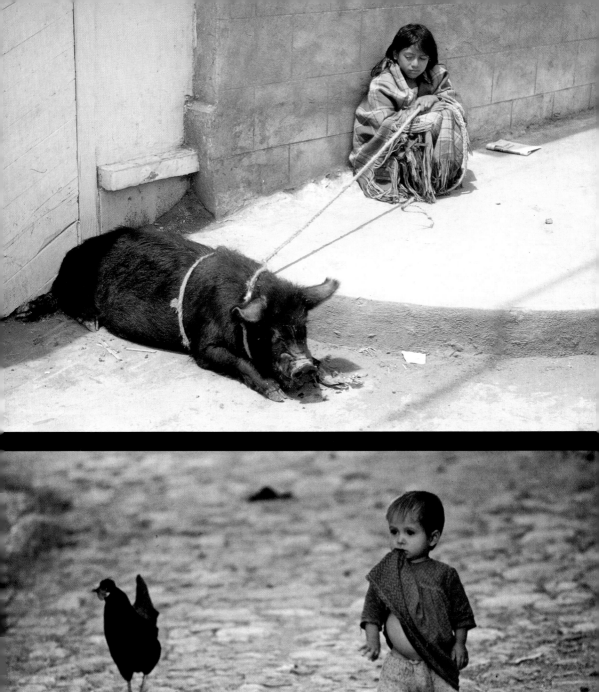

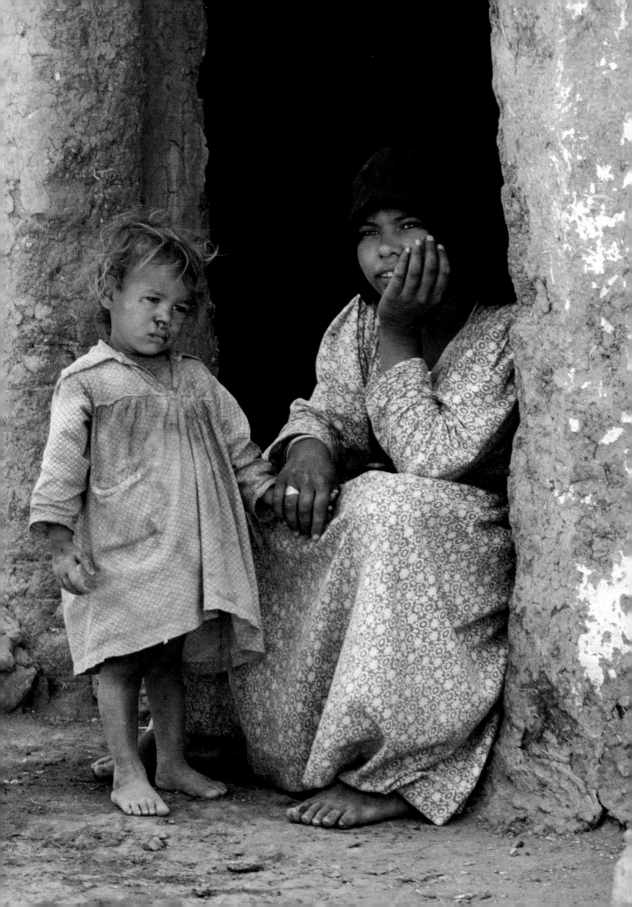

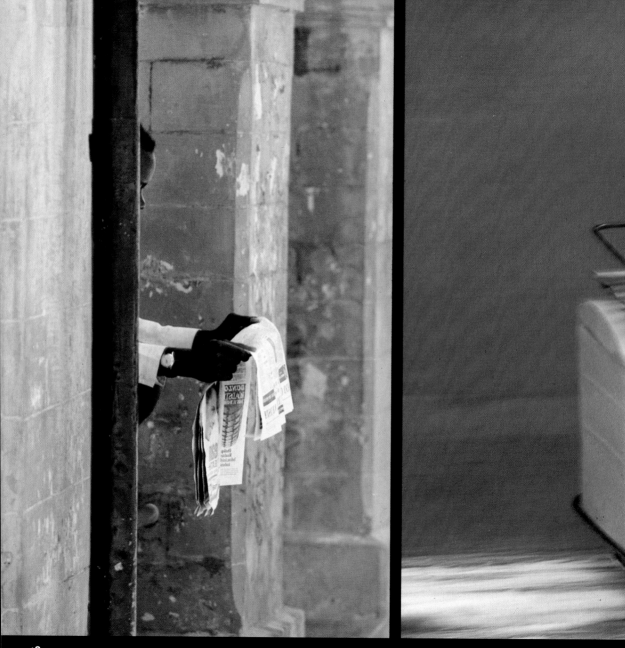

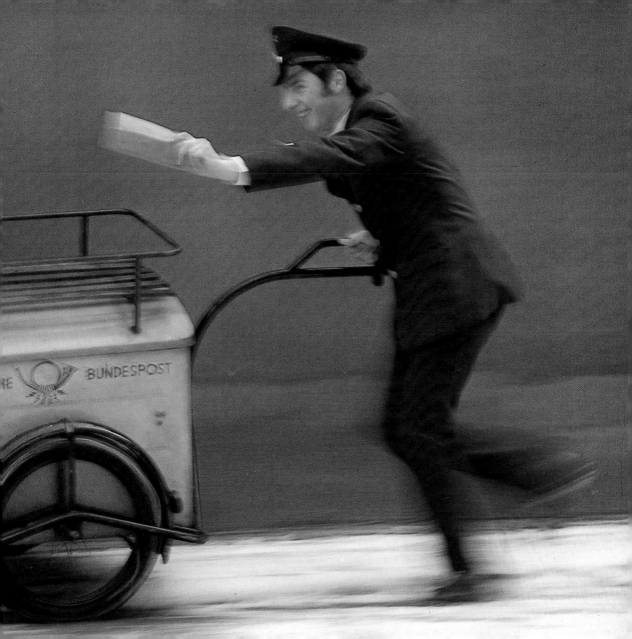

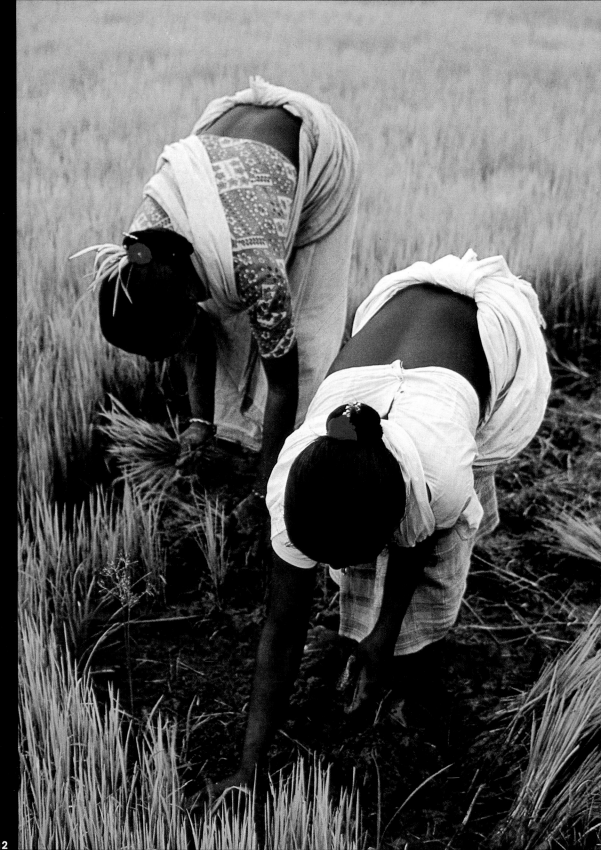

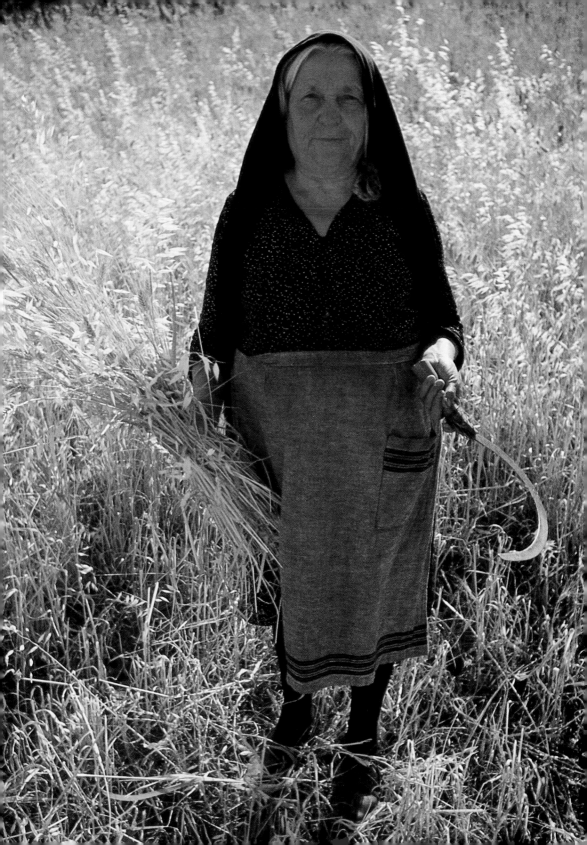

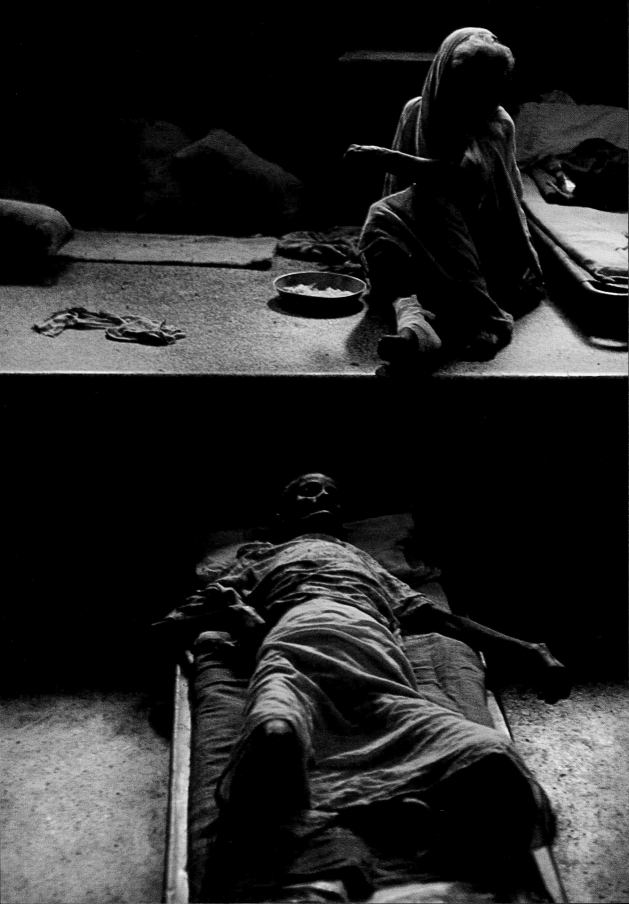

eople—Commentaries and Analyses

over picture: "The Career Girl"
chim Balon, Germany

e subject of a suitable cover picture
r a volume of photos is usually
scussed at an early stage of pro-
iction between author, editor and
arketing division of a publishing
use. Two vital aspects are of primary
portance: first, the signal effect of
e subject, which is meant to give a
ear indication of the contents of the
ok, and secondly the buying appeal
if you like, public taste. The book
ist appeal to a relatively wide reader-
ip through the impact of its cover
cture. Author and editor therefore
quire a flawless photograph, a master
ot which meets the highest criteria
message, form and colour. The
arketing division, on the other hand,
uld like to see a picture of a modern,
pealing girl in soft and warm colours
the cover. Out of half a dozen pro-
sed cover pictures, the "Career
rl" by the 26-year-old Stuttgart
otographer Achim Balon was finally
lected. His competition entry was
iginally photographed as an eye-
tcher. It was intended to serve as a
rt of stage set as part of a danced
shion show. The photographer had
en asked to photograph a vamp-
e yet cool-looking girl without
ming up with an everyday cliché.
ir cover photo proves that he suc-
eded in this. It is part of a series in
hich the model was taken in various
ses through three arched French
indows. Balon used an available-
ght film which—exposed at a
latively slow speed of 2 seconds—
ndered the subject in especially warm
ues (yellow and orange). Technical
ata: 50-mm Summilux-R 1:1.4 lens,
sec., f. 8 on Ektachrome X.

1 "Procession in San Francisco"
G. H. Pruitt, USA

The people of San Francisco celebrate
their religious festivals with enthusiasm
and passion. Gil Pruitt shot a Holy-Cross
procession and was fascinated by the
fervour with which the young men car-
ried a huge black wooden cross. He
needed all his skill —and elbow too —
in order to secure an advantageous
shooting position among the ecstatic
crowd. He finally succeeded in taking
this dramatic close-up with a 90-mm
Elmarit. The specific dynamism of this
photo lies in its movement, the fervour
and the expression of exhaustion on
the faces of the two young men.
Wedged in and pressed from all sides
they push ahead in the crowd. The
pouring rain which streaks their faces
intensifies the dramatic effect. Were
it not for their hippie-shirts one could
take it for a scene from one of those
giant, masterfully staged Biblical films.
Tech. data: 1/125 sec., f. 5.6 on Koda-
chrome 64.

2 "Crowds"
Ho Pak Kao, Hong Kong

The 21-year-old student who shot this
picture succeeded in producing a sym-
bolic representation which quite rightly
was awarded a first prize (subject:
People of Today). Ho Pak Kao reports
that he had several problems in taking
this picture. The scene of action is a
pedestrian zone near a Hong Kong
football stadium. Ho started out by
looking for a viewpoint above the scene
of action. He found it on the roof of a
small house in which he rented a room
for this specific purpose. After a foot-
ball match he waited patiently until
the seething mass of spectators reached
the place where he wanted to shoot

and where—as usual—the police
stood watching the crowd. The author
waited for the police to turn away
before taking this photo and he con-
sciously achieved this partly blurred
effect in order to emphasize the flow
of the crowd. Ho succeeded in this by
using a telephoto lens on his Leica CL
and an exposure of 1 second at f. 16
on Ektachrome 19 DIN and came up
with a prize-winning photo.

3 "Football Fan"
Toni Becker, Germany

Barbed wire sometimes is necessary to
set limits to the boundless enthusiasm
of modern man. Toni Becker took the
photo of this football fan (2nd prize)
in a Cologne stadium. He got a symbolic
picture—in content and message—
which needs no further explanation.
His sophisticated technical approach
deserves special mention: he inten-
tionally divided his picture into sharp
and blurred zones and in order to
achieve this he opened his 180-mm
Elmarit-R up to f. 2.8, which enabled
him to get a short depth-of-field and
at the same time the shortest possible
shutter speed in relatively diffused light
(1/60 sec. on Agfacolor CT 18) without
having to use a tripod. Toni Becker
added the following comment to this
picture: "In the match Cologne versus
Berlin the Cologne team had just
evened the score with a goal. While all
the photographers focused on the
goalie, I turned around to the spectators
and experienced this explosion of
feeling, the "People of Today".

4 "Fishing in Still Waters"
Fred W. French, England

It was an overcast, misty morning
when the photographer discovered

these two young fishermen. Mood and atmosphere were ideal for a romantic picture. Fred W. French was especially taken by the delicate reflection in the glassy lake and made it the subject of his photo. He expressly chose a vertical format in order to emphasize the graphic contrasts between the symmetrical structure of the horizontal plane and the asymmetrical vertical lines. For this reason the dark trees bordering the left-hand edge of the picture are particularly important in contrast to the landscape in its soft hues. Pink clouds are mirrored in the still water and the far banks merge hazily into soft meadows. Tech. data: 135-mm Elmarit-R lens, 1/250 sec., f. 5.6 on Kodachrome 64.

5 "Playing Boules on the Village Square"
Otto Wandelt, Germany
It looks as if the tree which dominates this picture were cemented into the ground. This impression is heightened by the wilted leaves which seem more cement-coloured than green. Perhaps it is simply the dull weather which colours everything grey. Boules players form a semicircle. They seem motionless, as if an invisible stage director had set them up as props. There is no feeling of the enthusiasm or fun which usually characterizes this game. A strange picture which fascinates the longer one looks at it. The bird's-eye view emphasizes the static, formal character of this photo. If it were not for the red sweater of one of the boules players it would not only be a monotonous but also a monochrome composition. The photographer wanted to achieve this formal order and obtained it by using a 35-mm Summicron lens on his Leica at 1/125 sec. and f. 5.6 on Agfachrome 50 S.

6 "Piggy-Wiggy"
Dölf Reist, Switzerland
The photographer is a Mount Everest veteran and one of the most successful mountain-climbers of our time. This photo was shot after having climbed the 19,360-foot-high Cotopaxi in Latacunga/Ecuador. He had mingled with the colourful crowd of a South American Indian market when he discovered this girl huddled against a clay wall away from the crowd.

She was holding a pig by a coarse rope, a strange pair. Reist quickly caught the scene with his Leica, and before the girl awoke from her daydreaming he had this snapshot in his camera. His 90-mm Elmarit permitted him to keep enough distance to his subject. The formal composition is very effective in its relationship of diagonal and horizontal elements while the turquoise door brings life into this picture. Tech. data: 1/125 sec. at f. 8 on Kodachrome 64.

7 "Two Runaways"
Edgar Ollmann, Austria
This original snapshot, which the photographer calls his favourite picture, brought prize-winning Edgar Ollmann his success. It is one of those pictures in which — no matter how good the photographer — luck plays a vital part in getting such a superb shot. Out of 5 photos which he shot within a matter of seconds, this is the best. He discovered his motif in a Turkish village during a summer holiday. The sun had already set and dusk was falling. Fortunately, the photographer had a highly sensitive film in his camera. Ektachrome High Speed (23 DIN) enabled him to catch his subject at 1/60 sec. and f. 5.6 with a 90-mm Elmarit R lens.

8 "Little Nepalese Girl"
J. A. Bottomley, England
J. A. Bottomley discovered his "Radish Girl" in Kirtipur near Katmandu in Nepal. He was taken by the naturalness and the charm of the Nepalese and photographed this little girl in the last rays of the setting sun. He focused on her over his wife's shoulder while she was talking to her and used a 135-mm Elmarit-R lens. Bottomley aimed his camera directly into the source of light which illuminated her hair against a completely blurred background. Focusing on her shaded face he used 1/125 sec. at f. 5.6 on Kodachrome 64, following the rule that photos taken into the light on a colour reversal film should be slightly underexposed.

9 "A Train Passes By"
Norbert Fanedel, Austria
One can't help being surprised to learn that this photo was taken from a moving train. The photographer was taken

unawares. This masterly snapsh proves once again that technical kno how can be perfected to such a degr that one can shoot a picture in passir There is nothing in this photo whi could have been improved on und "normal" conditions. It is now evide what the little girls in pink and th mother are watching: each day th wait expectantly for the train to pass b This photo owes its very special appe to its harmonious colours, the pink the dresses which is reflected even the shimmering blue of the clay wa Tech. data: Elmarit-R 1 : 2.8/180 m 1/125 sec. at f. 4 on Kodachrome X.

10 "News from Mombasa"
Henry Klein, Germany
"The first attempt at a frontal pictu with a 35-mm lens was defeated by t uncooperativeness of the newspap reader, whom I discovered in t milling crowd in the seaport town Mombasa/Kenya," writes Henry Kle about this picture. With a 90-m Summicron on his Leica he took anoth shot at what he was determined take home as a snapshot. This ill strates what adverse conditions c produce in the end, for this pho taken from the side most certain turned out a much more original sh than what the first try would ha produced. Only a second look reve all there is to see in this picture, for shows a newspaper reader on a toil seat. The emphasis on vertical lin gives this photo its special graph quality and charaterizes it as does t colour combination which compris only a few shades of blue and blac and white. Tech. data: 1/250 se f. 5.6, Kodachrome 64.

11 "The Love Letter"
Horst Reichl, Germany
The photographer had to hire th "flying postman" because postal se vices are not quite as fast nowaday Horst Reichl is himself a postal cler so he had no difficulty in persuadir a colleague to cooperate. He playe his role to perfection. Although th photographer used up a whole roll film, that is 36 exposures, the postm kept up a cheerful smile all the wa He seems as genuine as the who scene. The backdrop (green wa and the colour of the letter had be

sen carefully for harmonious colour
nbination. The blurred effect was
› rehearsed in several variations.
e final successful product was taken
h a 135-mm Elmarit-R 1:2.8 lens
/15 sec. and f. 5.6 on Ektachrome X
nned). This photo also illustrates
v varying degrees of movement of
limbs produce varying zones of
rredness (compare legs, hands and
d).

"Rice Planters"
K. Dhara, India
photographer from Calcutta shot
picture of two girls planting rice.
ept for the fact that he used a
caflex, he submitted no further data.
s does not really matter, for this is
mple snapshot which, however, is
king through its treatment of form
l colour. The scene was taken from
ghtly raised angle in very contrasting
t. This is why the few shaded parts
dly show any details, including the
en-black hair of the girls. The heads,
orned with red flowers, are graphic
ouettes. The massive green of the
e field looks like a carpet against
ich the two young women stand
like exotic coloured ornaments.

"Peasant Woman with Sickel"
o Wandelt, Germany
ece is Eldorado for amateur photo-
phers. This country and its inhabit-
s have retained that originality which
otographers value not only in their
rk. This quality characterizes the
hetype of a peasant woman who
n spite of her initial unwillingness to
e herself photographed—is com-
tely natural. She cooperated, as we
e from her friendly smile, her awkward

and somewhat naive pose. Otto Wan-
delt took great care to merge together
the peasant woman and the corn
shimmering in the sun. This is why he
photographed straight into the light.
Thus the shaded figure stands out
against the sunlight and the heat from
which she is protected by a black
headscarf. The sickel and the bunch
of corn in her hand are symbolic of the
life of a peasant woman. Tech. data:
35-mm Summicron 1:2.8, 1/125 sec.
at f. 5.6 on Agfachrome 50 S.

14 "House of Death in Calcutta"
Walter Keßler, Germany
A picture full of drama which the
photographer, so he assured, found
hard to photograph, but which he took
as a testimony of his experience. Walter
Keßler, editor of a Kolping magazine,
had been sent to Calcutta on an assign-
ment about refugee camps. His story
also took him to the "House of Death"
which is being administered by Mother
Teresa, a missionary who has become
famous for her selfless care for the sick
and the dying. Keßler describes this
place as follows: "Human beings were
lying on a sort of raised platform. They
were being washed and cared for, fed
and sometimes talked to by the nuns.
Everything was done with great calm.
We spent about three hours there and
watched and thought. It was like
meditating. I took two or three photos
while leaving, one of them the enclosed
scene." Tech. data: 50-mm Summicron
1:2 on a Leica on Agfacolor CT 18.

Editor's Note:
To what degree the photographer
dealing with human beings may
manipulate his subjects—like a stage
director masterminding the action—
is a question which is asked again and
again. It is impossible to give a single
answer. The photographer who values
authenticity will only intervene when
this does not interfere with the general
activity and when he does so, then
only because no other technique,
however sophisticated, would enable
him to achieve the desired result. As
far as technical quality is concerned a
direct comparison between a posed
and a natural scene of equal quality
the decision usually is in favour of the
genuine scene. In photos 10 and 11
two motifs of this kind are juxtaposed:
they are photos of general interest
which produce the desired result even
though the photographer staged them
to a certain degree. Yet the experienced
judge can pick out the staged scene
immediately. In pure amateur photo-
graphy, artistic staging for the sake of
practice in composition is completely
legitimate. It is useful simply for the
reason that the trained amateur photo-
grapher can master similar situations
should they arise in real life.
An international team of jurors is
expected to identify staged photos.
Such a jury will always decide in favor
of a genuine scene except in cases
where a manipulation was expressly
asked for, such as in the contest
"50 Years of Leica", subject group 4
(My Most Beautiful Photo) where it
was part of artistic technique. Other-
wise, the superb sandwich montage
(picture no. 75) would not have won
first prize in this subject group.

Colour Portraiture——Live and Posed

The picture of a person, a portrait, is a moment of the past made visible. "Man has a thousand faces" is the classic way of summing up the interplay of past and present reflected in a person's face. In fact each person has numerous faces and none are identical. Mirrored in a face, human life appears as the passage of a series of moments of experience. Portraiture is the photography of a moment, and the photographer must act swiftly to capure the right moment with his camera. The individual who goes to a studio to have his picture taken is prepared to give his face away for single moments. But he doesn't offer his real face, only his photographic face. Nevertheless talented photographers now and then succeed in taking a good photo, a real living portrait.

In the case of live portraits such as those reproduced on the following pages, this problem rarely if ever arises. None of these pictures were taken in a studio or with artificial lighting, not even the young lady reflected in a mirror pictured on the opposite page. This is the only photograph in this portrait series that was taken indoors. It was taken in bright daylight coming through the window and it is unquestionably a good modern portrait, a young, tender, spring-like face. We can assume that the lady is satisfied with her portrait. Why do studio portraits turn out so different, so unsatisfactory, lifeless, static and dull? The answer is simple: photographic routine makes the faces all the same; thousands of portraits are taken there, all made to fit a given pattern, a typical photo face handed down from generation to generation.

Live portraits are studies of people in action: travelling, on holiday, chance encounters. They are portraits created without a director's hand——and where the photographer has had a hand in it, as in pictures 19 and 20, then mainly in composition and setting. In these two pictures the arrangement made by the photographer cannot be ignored, but that is of no concern. The relaxed facial expression and the improvised nature of the setting make the photograph seem a chance encounter. The natural posture (picture 19) and the expression of curiosity (picture 20) make it easy to forget that the pictures were posed. And the colours in these two child portraits, despite their pronounced formality, always lead the eye back to where life is reflected in these faces——to the eyes. As in all good portraits they determine the mood and the expression.

Pictures without direction on the part of the photographer are usually taken as quick snaps. They save the photographer the direct confrontation with the subject, the psychological approach, with the result that tension, affectation and posed, unnatural expressions are eliminated. Real unadulterated live portraits result——even a portrait documentation, as usually a whole series of photos are taken. Using longer focal lengths, the photographer can operate from a distance, unobserved by his "victim", who acts quite naturally since he is unaware that the camera is on him. All the prerequesites for a live portrait are fulfilled; but it sounds easier than it is. There are difficulties of a different nature, namely in technique, such as taking photos from a hiding place without being seen. Newspaper reporters know all about these problems. The successful snapshot portrait taken from a distance——the face of a politician, TV star, Olympic winner picked out from among a crowd——are among their most difficult assignments.

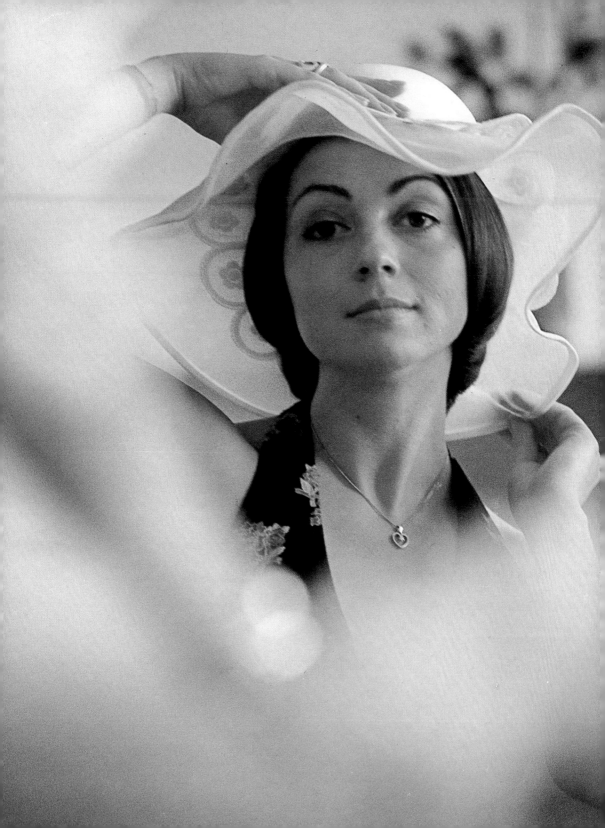

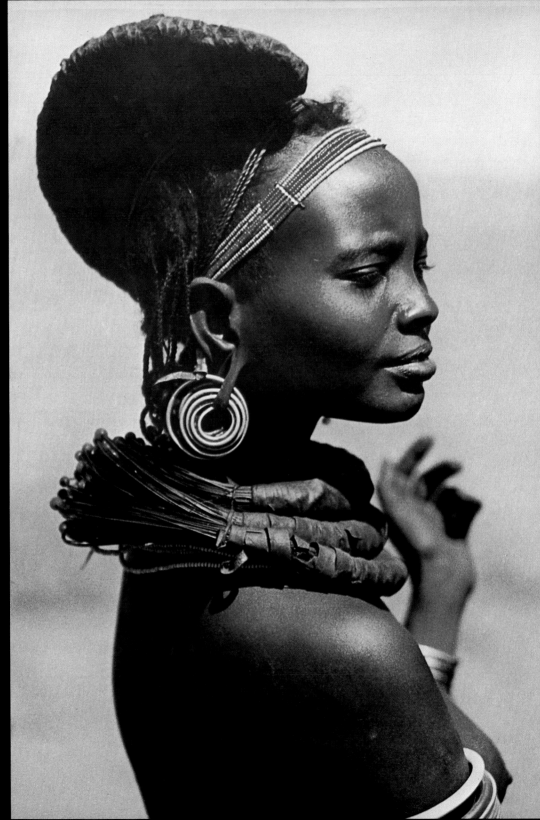

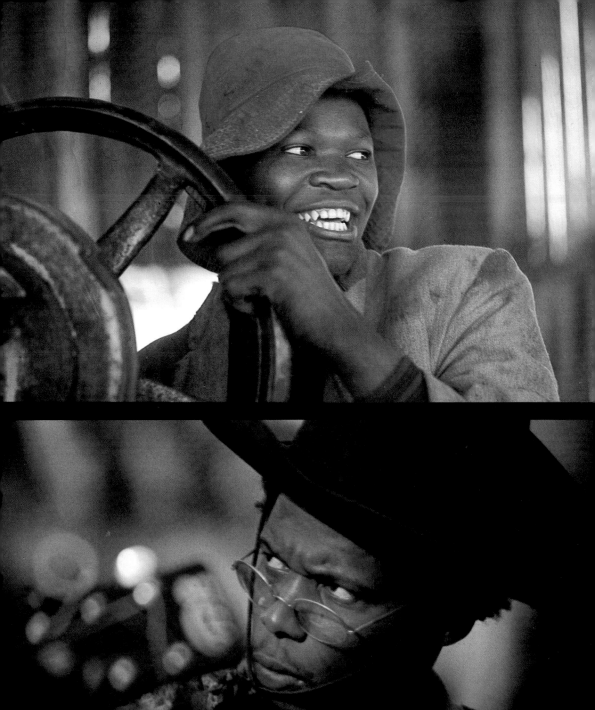

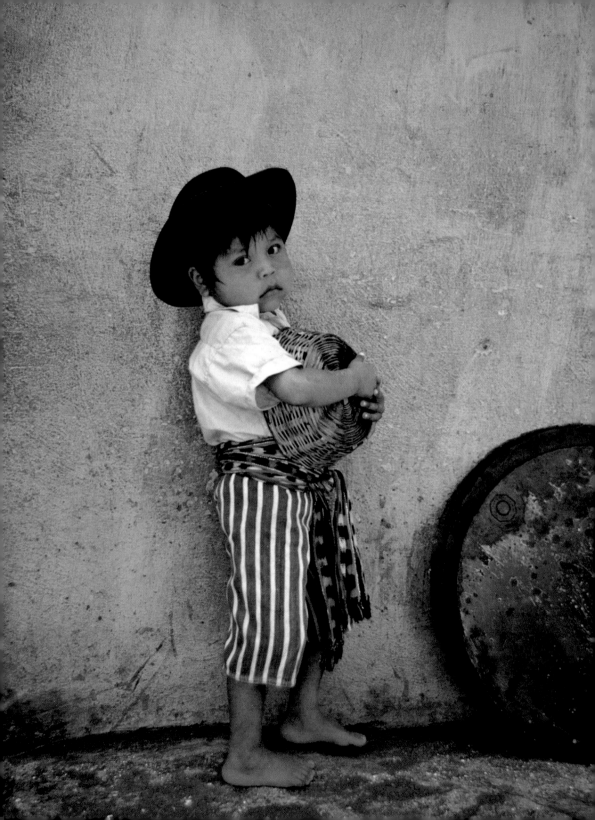

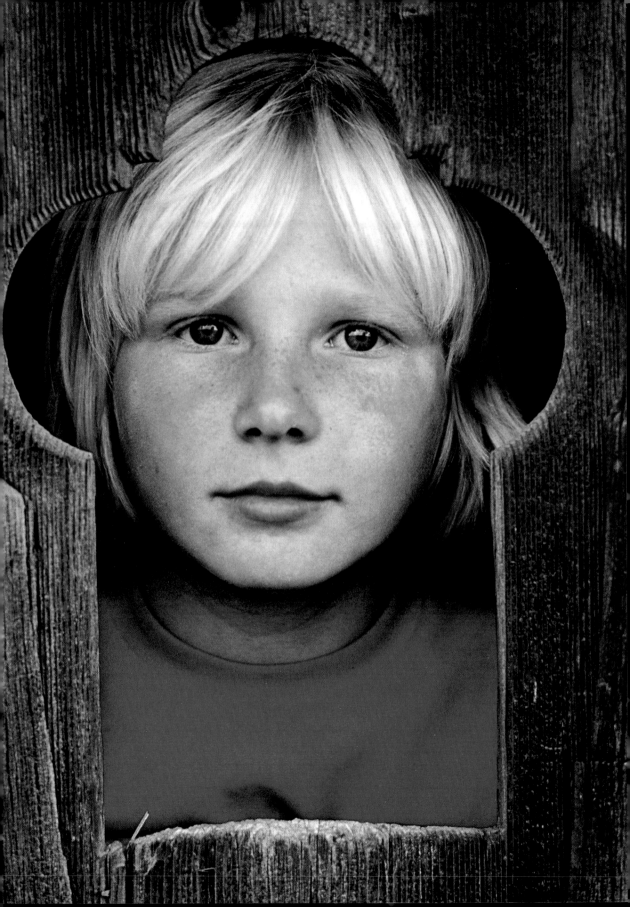

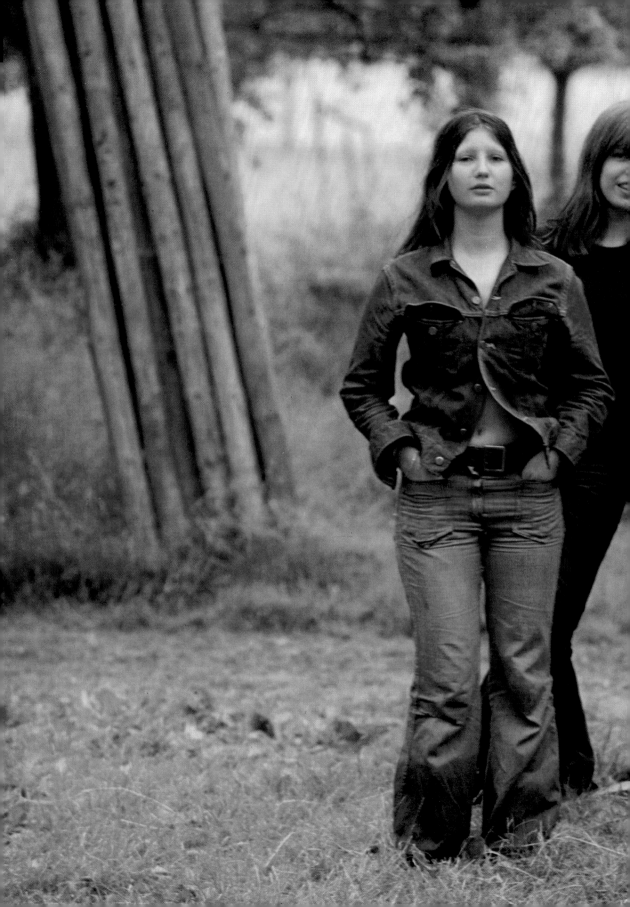

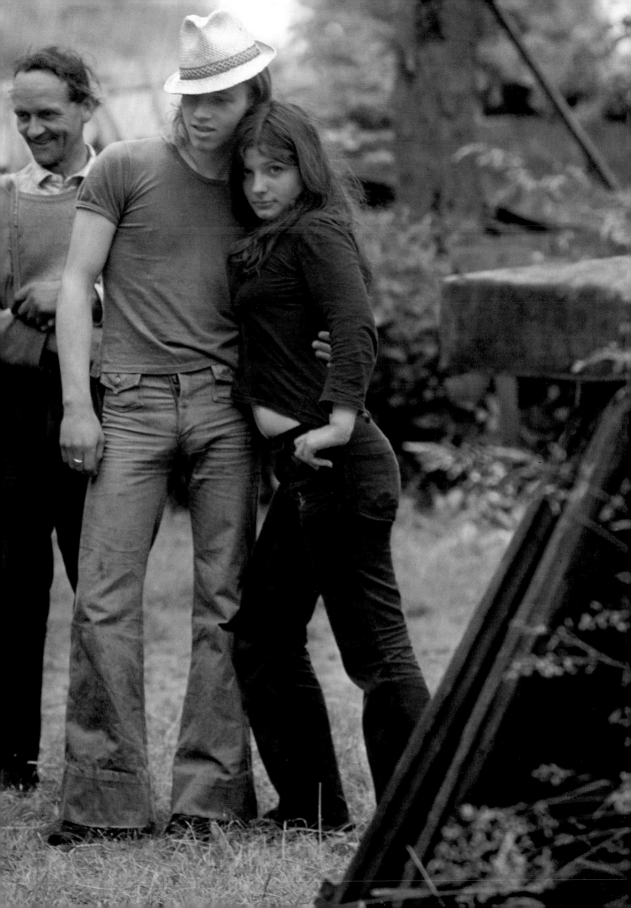

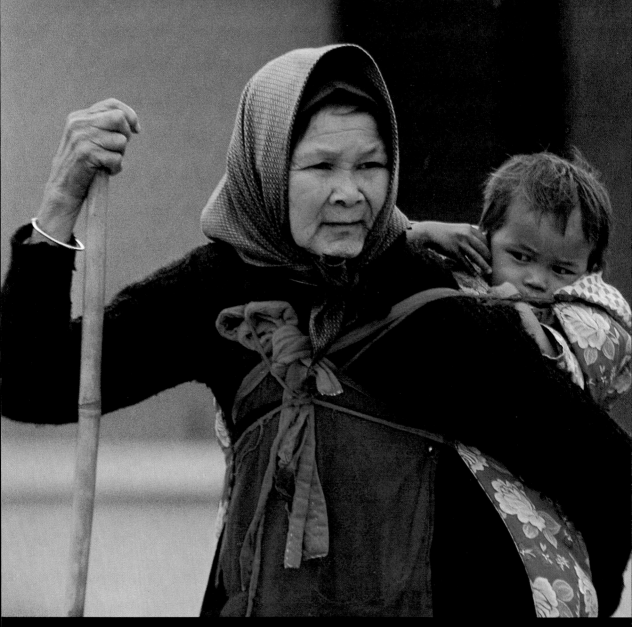

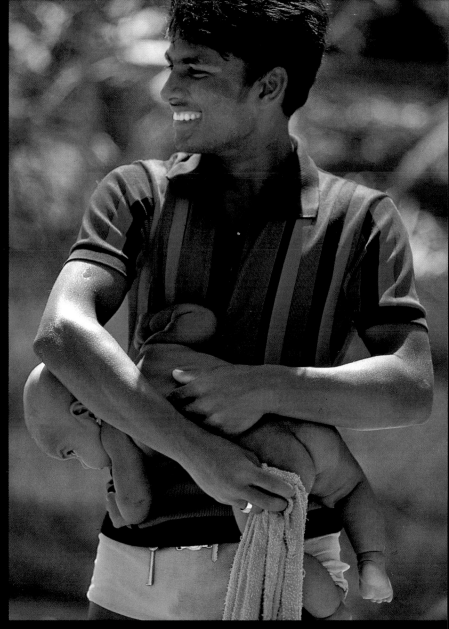

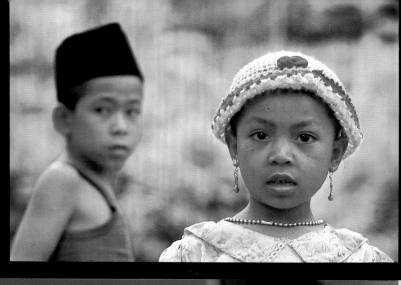

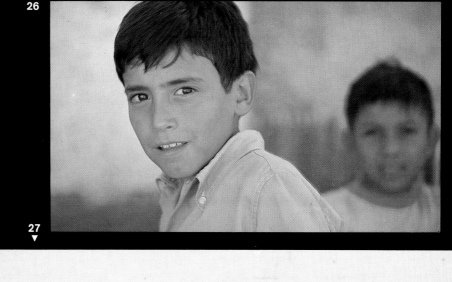

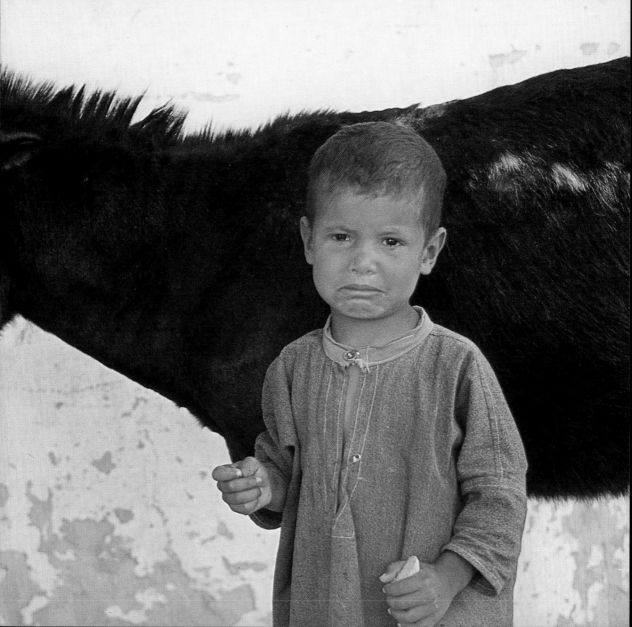

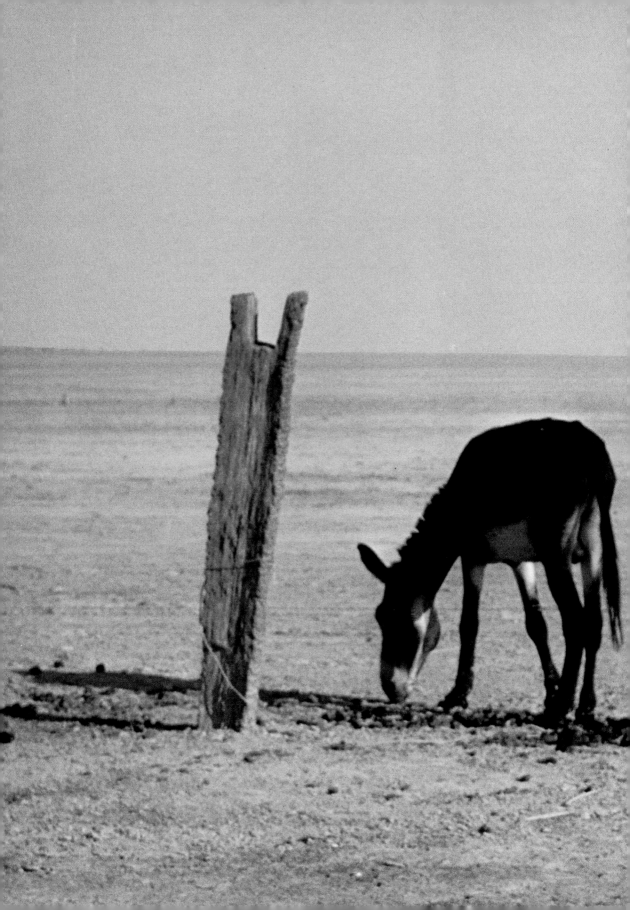

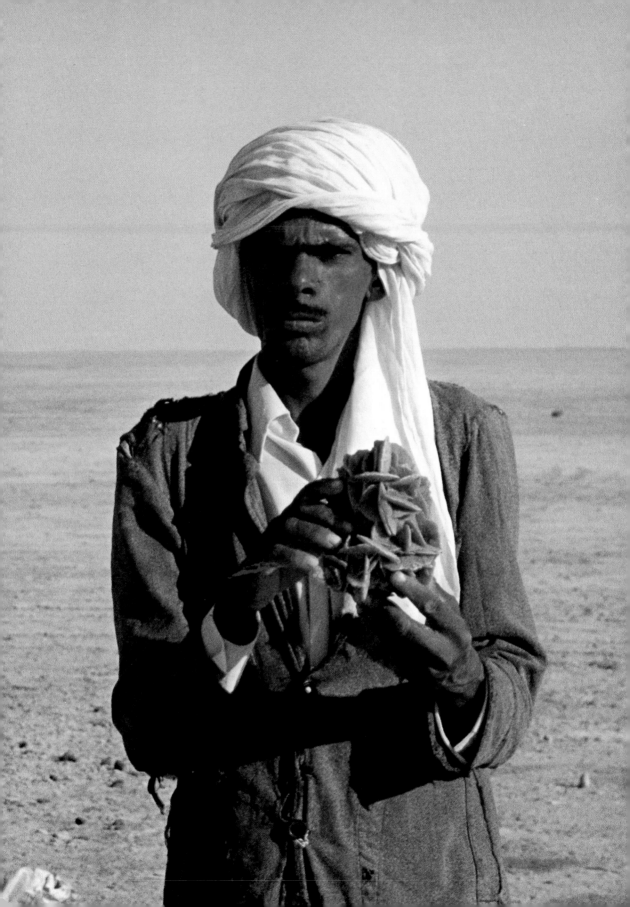

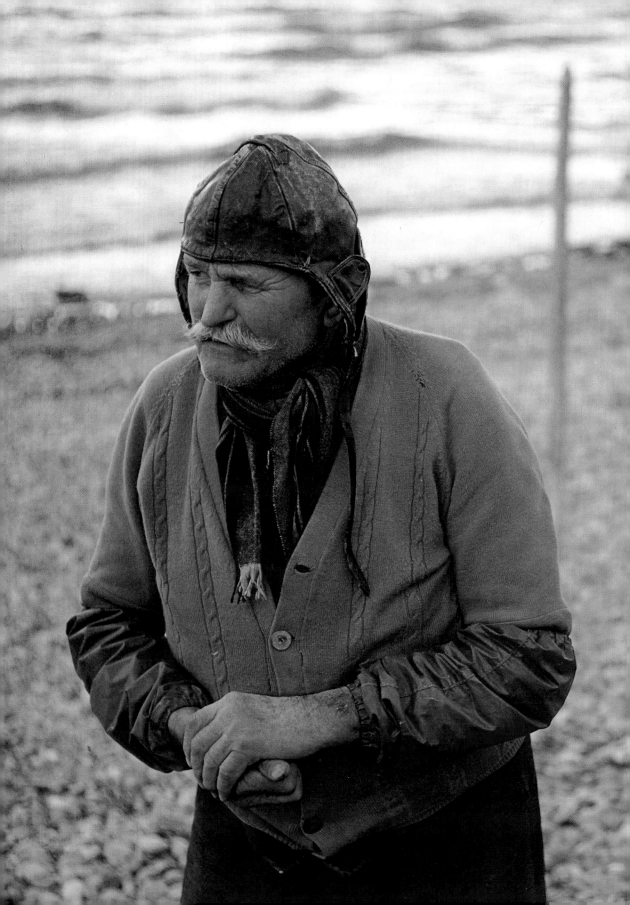

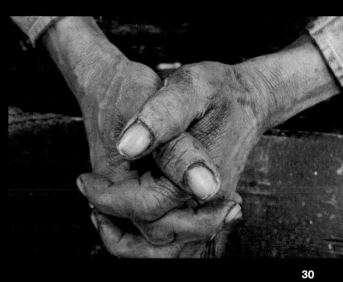

"Looking Glass"
us Merfeld, Germany
e "Lady With the White Hat" was
otographed in front of a large mirror
m a table tripod. Klaus Merfeld used
eica with a Visoflex II and the 135-mm
narit 1 : 2.8 lens. He wanted a portrait
a woman of today — "young,
autiful, emancipated and full of
f-confidence". This is how he de-
ibed his model. Her pose is not
problematic, for her hand reaching
her hat exposed her armpit. The
otographer eliminated this area with
rick with a mirror. He arranged the
per arm of his model — blurred in
e foreground of the left-hand part of
e photo — in such a way that it
literated the critical area in the mirror.
e transparent quality which in colour
d perspective is the special charm of
s picture is emphasized by a chry-
nthemum, dissolved into a yellow
otch of colour in the foreground. The
oto was taken in daylight, a white
ll was used to intensify the lighting.
ch. data: 1/30 sec., f. 2.8 on Agfa-
rome 50 S.

"Beauty"
alter Spiegel, Germany
is "Dark Beauty", whose helm-like
irstyle enhances her elegance,
peals through her natural grace and
affected pose. Walter Spiegel met
s young girl from the Rendille tribe
ar Lake Rudolf in Kenya. The intensive
ht conditions (obviously not direct
n) divides shoulder and head into
ongly contrasted light and shaded
nes which result in a woodcut-like
ect (stark light-dark contrast). Her
e wears a slightly guarded expression
d the pose of her hand speaks of

self-confidence. Walter Spiegel focused
on her earrings which are a continuation
of the braiding of her hair and end in
the heavy necklaces. The soft contours
of her hand illustrates how fast the
depth-of-field diminishes. Tech. data:
Leicaflex SL with 90-mm Elmarit-R,
1/125 sec., f. 4 on Kodachrome.

17 "Scarlet and Black"
Juul Denecker, Belgium
The red hat is what caught his fancy.
Juul Denecker discovered it while
visiting a sawmill on a trip to the South
African National Park. He saw the boy
who was busy at a steering wheel.
When he noticed that he had been
discovered he gave a wide smile. But
it was difficult to get a satisfactory shot
under the available lighting conditions.
He opened his 90-mm Elmarit up to
f. 4 and tried it (to be on the safe side)
at 1/125 sec. (Agfacolor CT 18). The
picture did not suffer at all through
slight underexposure. Denecker calls
this his most beautiful photo. But this
is not why it deserves admiration — it
is the daring composition: the segment
of the steering wheel and the light
reflections on a wooden wall in the
background. These traces of daylight
are counterbalanced by the light
reflections between the spokes of the
wheel.

18 "Boy Scout"
Thomas Pötzsch, Germany
The glasses had just slipped down his
subject's nose when Thomas Pötzsch
pressed the shutter. The neck of a gui-
tar is visible in the left foreground. This
is an excerpt from a group of young peo-
ple whom the photographer discovered

near Notre Dame in Paris. Pötzsch who
almost exclusively photographs people
favours the extreme 21-mm Super-
Angulon-R on his Leicaflex SL. "It
is the only kind of 'Verfremdung' which
I accept," he says. The portrait of this
Boy Scout proves what can be done
by filling the viewfinder right to the
edges. Only the rim of his black hat is
visible, and it is counterbalanced by
the shadow zones on the bottom corners
of the picture. His light-brown face
with eyes peering over the glasses
looms out of the dark. Tech. data:
1/250 sec., f. 5.6, Agfacolor CT 18.

19 "Small Boy With Basket"
Gunhild Blauert, Germany
Women have a special talent for taking
children's portraits. Gunhild Blauert,
a pharmacist from Hamburg, shot this
portrait of a winsome boy which, in
spite of masterly arrangement, retains
this candid quality which is characteris-
tic of a successful snapshot. The picture
is proof that especially in children's
portraits strong colours are desirable.
The turquoise wall is the dominating
colour in this picture. Beige, violet and
red in the boy's clothing add up to a
harmonious, vivid colour combination.
The rusty iron lids are an important
factor in this composition, because they
break up the flat background and
become a focal point in the picture.
Tech. data: 90-mm Elmarit 1 : 2 on a
Leicaflex SL, f. 8 at 1/125 sec. on
Kodachrome 64.

20 "Astrid"
Edgar Ollmann, Austria
The prize-winning photographer could
not bring himself to simply photograph

Astrid, maybe against a blue sky, and so he went in search of a suitable set which he discovered in an old tumbledown house: an ornamental peep-hole in a wooden wall. It made an ideal frame for this handsome blond head. "The weather-beaten wood, the straw-blond girl with her red shirt, her merry blue eyes and jolly freckles were pure harmony," says Edgar Ollmann. He took various shots on colour-negative and colour reversal film. The shirt glowing red from out of the dark is the main colour focus in this slide, which owes its appeal partly to the superb technical quality and colour intensity. Tech. data: 90-mm Elmarit-R 1:2.8 lens on a Leicaflex SL, f. 5.6, 1/60 sec., Kodachrome 64 (tripod).

21 "Youngsters in Jeans"
Beate Meyer, Germany

"We had only known each other for a few minutes, the farmer, the three sisters, the boyfriend and I. It was in the yard of an old mill, and in spite of all the junk an ideal place for playing. The farmer, however, was not very enthusiastic initially. But after a while, we had broken the ice and the result was this shot. The short moment in front of the camera had afforded the farmer a small respite from his work and he ended up by enjoying it." This is how Beate Meyer describes the story behind her photo. She succeeded in interpreting "People of Today" in a convincing manner. Group pictures are always a risk, more so than a snapshot. Beate Meyer is a student of social pedagogics and some of her experience in dealing with people is visible in this picture. There is nothing unnatural, no artificial pose, and yet everything is just right. The poles in the left-hand background and the boards in the right-hand corner act as a frame. Tech. data: 135-mm Elmarit-R on a Leicaflex SL, 1/125 sec., f. 4, Kodachrome 64.

22 "Mother Figure"
David W. C. Yuen, Hong Kong

This is a superb composition, magnificent in content, form and colour. The face of this woman expresses self-confidence, pride and at the same time submissiveness. The hand on the bamboo stick tells of heavy physical work, her bent back of the burden of life. The infant rests securely and safe in her scarf. The mother's hand reaches back, as if to make sure that the child is safe. Yuen selected his close-up very carefully. The graphic background, slightly blurred, seems made as a stage set for such a live portrait. Depth is emphasized through the sharp contrast in focus. The woman's blue scarf, the light faces of mother and child are contrasted against the olive-green background. Where the strong horizontal plane in the background lightens in the lower part of the picture, lines and flat areas intersect. They do not interfere but enliven the composition. The woman is placed in the left part of the picture so that enough space is left around the face of the child. Tech. data: 135-mm Elmarit-R 1:2.8, 1/125 sec., f. 5.6, Kodachrome 64.

23 "Father from Ceylon"
Herbert Pempelfort, Germany

"I'm sure that you agree that not all fathers in this world are as picturesque and naively happy as the one I photographed in Ceylon," writes Herbert Pempelfort. The jury of the Leica contest also liked this modern Ceylonese with his shiny teeth, his smart moustache and his radiant face. The way he holds his baby, too — so natural and carefree — speaks of a father's joy. The picture is more than a good snapshot, for the photographer shows how the subject of "Father and Son" can be approached from a different viewpoint. This picture might serve as an example, because it is time to bid farewell to all those posed pictures of possessive father and mother figures and of children's faces frozen into unnatural smiles. Tech. data: 50-mm Summicron-R lens on a Leicaflex SL, 1/250 sec., f. 5.6, Kodachrome 64.

24 "Double Portrait"
O. Hussein Tanzil, Indonesia

This winsome portrait comes from Bandung. It shows that the photographer is not only a professional but also that he is an expert stage director who succeeded in evoking an expression of wonder on the faces of these children. In arranging pictures with children the correct psychological attitude of the photographer is v important, because the natural fac expression is what one is after, Tanzil shows in this picture. Added this is the skillful play with sharp a out-of-focus areas. Optically, the dominates the foreground, her fa alone is in focus. The boy on the lef slightly blurred but still recognizab Unfortunately, the photographer su mitted no technical data.

25 "Chinese Boy"
Jean Keup, Belgium

This photo was taken in the city Peking in March 1975. It was Je Keup's first visit to this mysterious c in the Far East and he photograph in a part of the city which is norma closed to foreigners. He was amaz to find imaginatively and colourfu dressed children among these rat uniformly clothed people, and t magnificent, proud Chinese boy, who he discovered in front of one of numerous temples, caught his e He looked very self-confident in pale-coloured jacket and his jolly sc His small frame was effectively silho etted against one of the bright pillars. Jean Keup, who carried camera hidden under his jacket, ac fast and shot this unique scene with 28-mm Elmarit-R lens on his Leic flex SL. He evidently had to bend dov in order to take this at eye-level w the boy. He cannot remember furth exposure data.

26 "Big Brother"
Per Wyholt, Sweden

The composition of this photo reminiscent of the double portr reproduced under No. 24. Technic data is probably rather similar. F Wyholt, a mining engineer from Lu in Sweden, photographed this sce in Mexico with a Leicaflex SL and 90-mm Elmarit-R. In order to limit t depth of field he set his lens at 2.8 a exposed 1/125 sec. on Kodachrome 6 Thus the boy in the background recognizable, yet out of focus, wh his big brother is in focus and domina the foreground. The harmonious colc tones and the restrained use of bl shades alone are particularly admirab in this picture. The photograph

ntions that the sunlight reflected a white sandy beach and up to the ᵥ leaning over a balcony. Per holt photographed this scene in ᵢsing.

"The Boy With the Donkey"
Klaus Franke, Germany

е photographer, a doctor from Bad ᵢnach, discovered his motif on a trip ᵢugh Tunisia at the market of the ᵢuz Oasis on the edge of the Sahara ᵢsert. The boy stood forlornly with donkey in front of a house with ᵢmbling walls. When he noticed that was about to be photographed, he ᵢrehensively posted himself in front the animal. He was close to tears. Franke tried to put the boy at ease giving him a mandarin orange and ᵢckly took this photo. He chose a se-up, for the composition of this ᵢture is important. He placed the ᵢnkey like a silhouette against the ᵢght wall and the boy in the right-ᵢd third of the picture, thus achieving ᵢalance in spite of the asymmetry. ᵢh. data: Leica CL with 40-mm ᵢmmicron 1:2, 1/125 sec., f. 8, ᵢfacolor CT 18.

"Schott el Djerid"
ᵢlfgang W. Itter, Germany

е photographer of this picture was ᵢcinated by the face of the Arab who ᵢntly offered his "desert rose" against ᵢ background of a vast desert and a ᵢnkey tied to a pole. A Biblical scene. е intense light forced Wolfgang Itter look for a favorable position which ᵢuld also enable him to bring the ᵢnkey into the picture. The glaring ᵢ draws long dark shadows and ᵢides the face into light and dark ᵢctions. The scene was taken from a ᵢuatting position so that the horizon ᵢs about level with the man's shoulders ᵢd his face was contrasted against ᵢ pale sky. Tech. data: Leica with ᵢ-mm Elmarit 1:2.8, 1/500 sec., f. 8, ᵢfachrome 50 S.

"The Old Man and the Sea"
ᵢ Bert Wilden, Germany

е title of this picture is, of course, allusion. "I thought of the Heming-ᵢy novel when I saw this fisherman,"

writes Dr. Wilden. The man, the boat and the beach are a typical setting. This is not the sea, however, but Lake Constance where the photographer spent a holiday. He took a classical live portrait of a fisherman shown in his natural element: water, wind and his boats. Wind and the cold have reddened his face and hands. He is cold and rubs his freezing hands. The asymmetrical composition is interesting: the fisher-man in the foreground is walking past the camera and out of the picture towards the left. In spite of the fisher-man's calm and composure this is a very lively picture because of the expert composition which puts the man, the beach, the boats and the vertical poles into striking perspective. Tech. data: Leica with a 135-mm Elmarit, 1/125 sec., f. 4, Kodachrome 64.

30 "Labourer's Hands"
Erich Klemm, Germany

These are the hands of a shoe-shine boy whom Erich Klemm met on a trip to Tunisia. "He followed me with his shabby wooden box full of worn-out brushes and dried-up shoe polish tins wherever I went. Since he was so friendly I took to liking him. Never again in my life did I wear such shiny shoes as in those days. And one morning I took a photo of his hands." This description explains a lot. But why did he only photograph his hands? Probably because they say more about the man than his body or face. The way in which he holds his hands, submissive, waiting, is very expressive. This prize-winning shot, though not a portrait, is a symbolic image of a man's life who knew only one thing in his struggle to earn his daily bread: work. Note the bold cropping and the near-monochrome colouring. Tech. data: Leicaflex SL with 50-mm Summilux-R 1:1.4, 1/60 sec., f. 11, Agfachrome 50 S.

31 "Young Tuareg"
H. C. Parmentier, Holland

This dark beauty is a young boy from the tribe of the Tuareg, the descendants of the famous Hamitic nomads of the Western Sahara. This youngster's dreamy gaze is full of melancholy, blue is the dominating colour. There is a lovely colur contrast between his

face, the remnants of a blue shirt (on his shoulder) and the expertly wound turban. The 135-mm focal length (and a rather wide aperture) achieved the washed-out bluish effect of the back-ground which serves as a backdrop to the finely chiseled face in the foreground. The boy's natural grace and pensive look are what distinguishes this por-trait. Tech. data: Leicaflex SL, 1/250 sec., f. 4, Kodachrome 64.

Editor's Note:

Colour film producers who recommend their products as "especially suited for a neutral rendition of skin tones" usually know what they are talking about, for photographing naked human skin is one of the most delicate problems for a photographer. This is also the reason for the contention that the public prefers a portrait or even a nude in black-and-white because it transforms ugly red noses and sallow skin into a mild, noble and soft grey. Accom-plished colour photographers try to artificially improve colour portraits with skillful lighting, the use of filters or heavy make-up and often achieve good results. Really successful live potraits, however, as pictured on these pages, are shot without colour mani-pulation. Very good results were ob-tained with colour reversal film from a wide range of firms. Not even bright intensive colours produced by the position of the sun at a given time of the reflection from the surrounding area had to be filtered out, retouched or specially intensified in these portraits.

The Poetry of Landscape in Colour

The world is beautiful — a tribute to nature if we apply this observation to landscape. Mountains, meadows, forests in spring, summer, autumn and winter are the subjects which enjoy the most attention, even the love of the amateur photographer. Cityscapes are another matter. Though designed, shaped, built and inhabited by man, they too can be beautiful, full of atmosphere, dramatic or romantic. It is worth investigating every corner of them with the camera. Cities are a world of their own; many photographers are unaware of this and prefer to ignore them.

Landscapes head the list of subjects in amateur photography. Nearly 90% of all colour slides developed in commercial laboratories are landscapes. And although millions and millions of slides are taken, most simply cannot compare with the photographs published here. Landscapes are not all the same and there is skill required in using colour. Simply pointing the camera in the right direction is not enough. Ambitious photographers pay attention to the colour composition of the picture. This is not to say that the snapshot cannot — by chance — turn out to be a masterpiece, with all the characteristics of a prospective prizewinning entry.

Miracles don't happen in photography either; they take even an experienced landscape photographer somewhat longer. Chance rarely brings him the unforeseen moment that results in a perfect picture.

The nature photographer constantly examines the landscape. He must study and photograph it in all its variations before he might be lucky enough to win a competition. The best example is the prizewinning photograph in the theme "Landscape", an extremely subtly coloured sunset (picture 33). The photographer described his "preparatory work" as follows: "Ever since I took up photography, I've been particularly interested in landscapes, atmospheric phenomena and sunsets. Over the last few years I have taken photographs of countless sunsets with a variety of techniques, several different lenses (from a 15-mm Hologon to a 400-mm Telyt) and all kinds of filters." His prizewinning entry was preceded by countless experiments and years of preoccupation with the theme. It was the practical experience in technique, the analysis of the specific exposure problems of sunsets that led to this picture which was finally selected from hundreds of sunsets and all the landscape photographs for the first prize.

The right approach to light and composition down to every detail of form and colour are crucial in landscape photography. One of the basic rules of black and white photography is that form and content determine the effect of a photo. Colour is yet another dimension, which develops a vitality of its own and adds a dynamic effect which strongly influences the composition. It can be varied by stressing the light or by the interplay of light and shadow, or by photographing against the light or even straight into the sun, when light achieves dominance over form and colour (e.g. pictures 32 and 39). It takes courage to photograph such light effects in colour and they rarely find the recognition they deserve by being published.

The world is full of colour; but the ambitious photographer selects only two or three colours to dominate the scene — usually a colour combination which is typical of the subject. Extremely sparing use of colour, even monochrome pictures characterise the good landscape photographer. Even photos which would make good black and white pictures such as picture 55 (Snow-covered boat) with its various grey, blue and brown tones, have a delicate range of colours which it would be a shame to eliminate. Subjects suitable for black and white film only are the exception. Colour is everywhere, in almost everything we see.

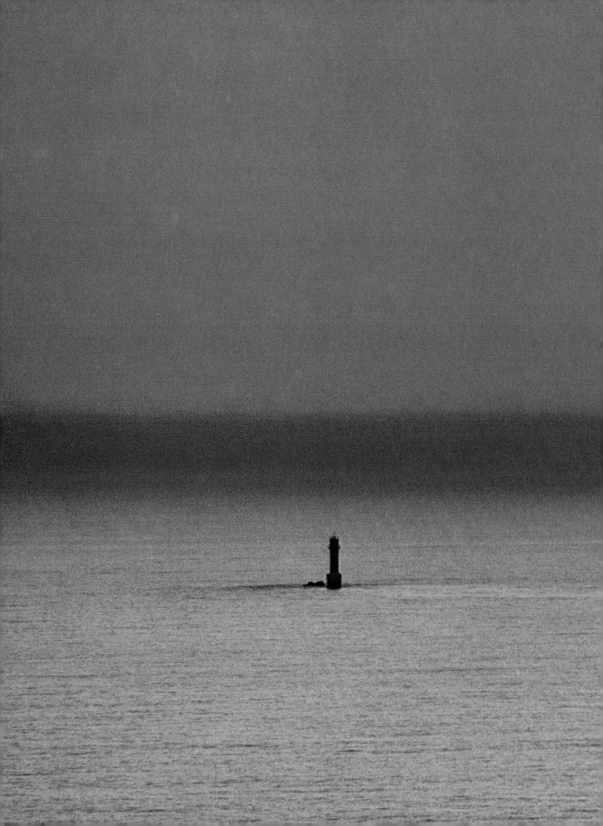

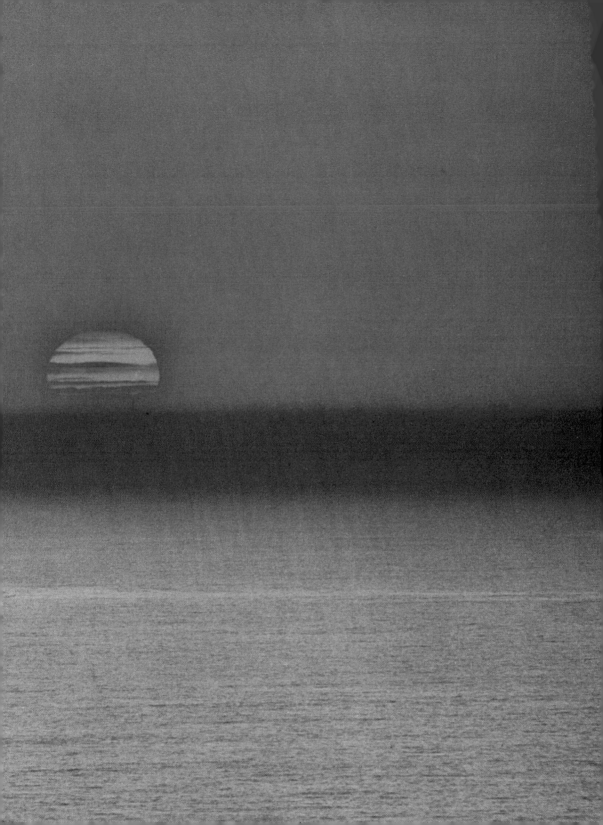

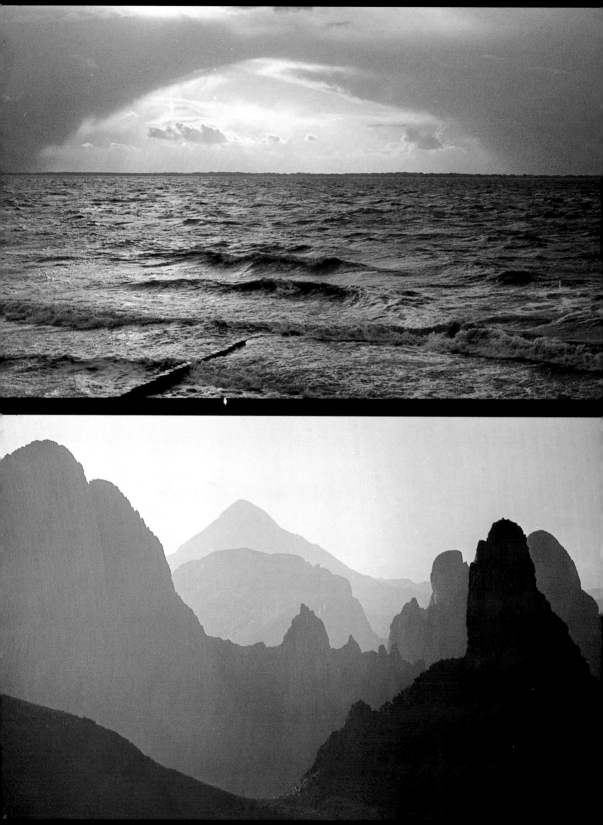

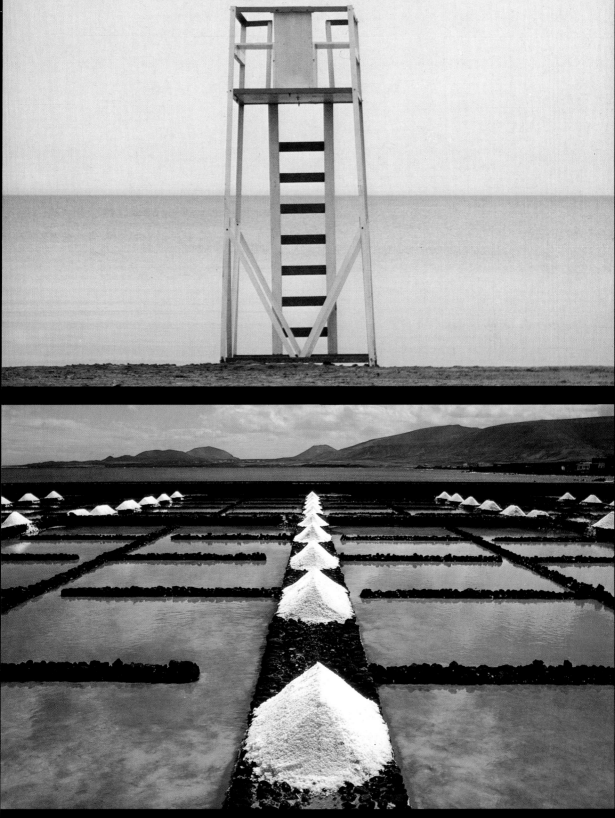

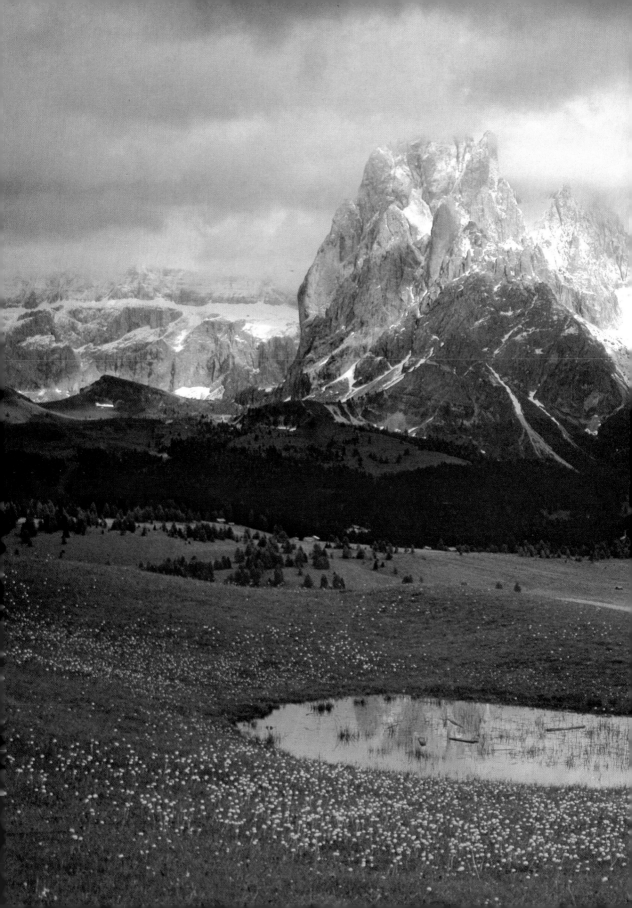

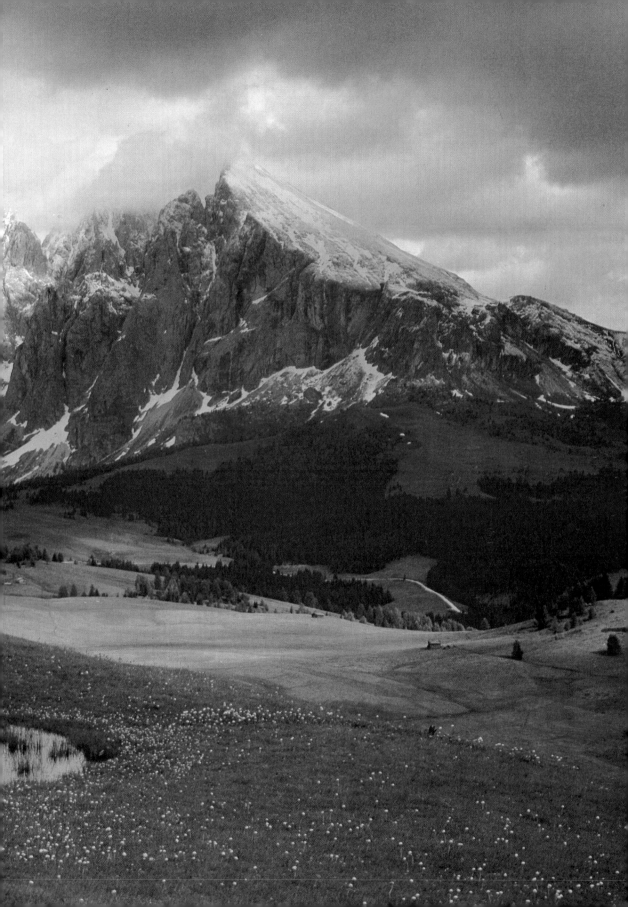

42

45

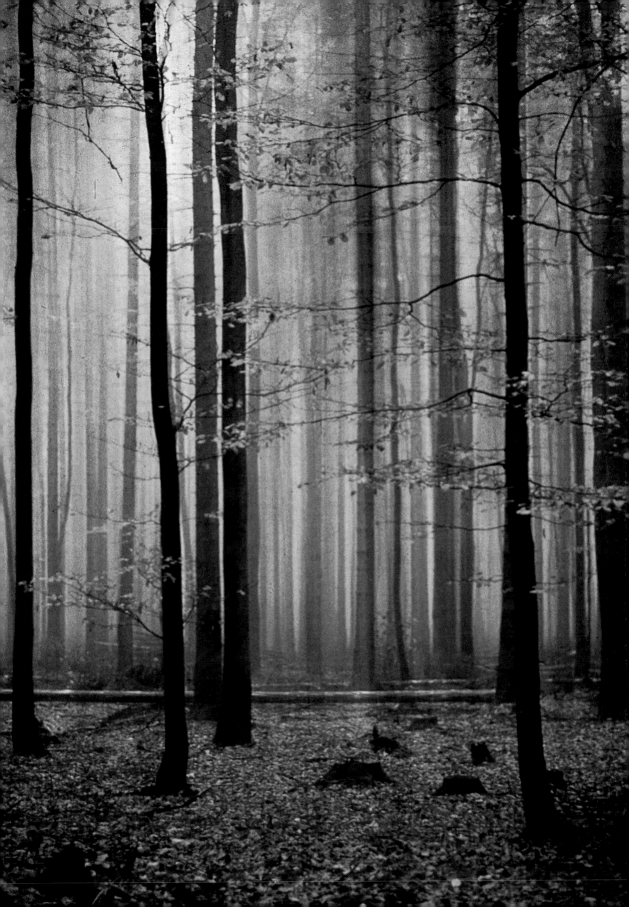

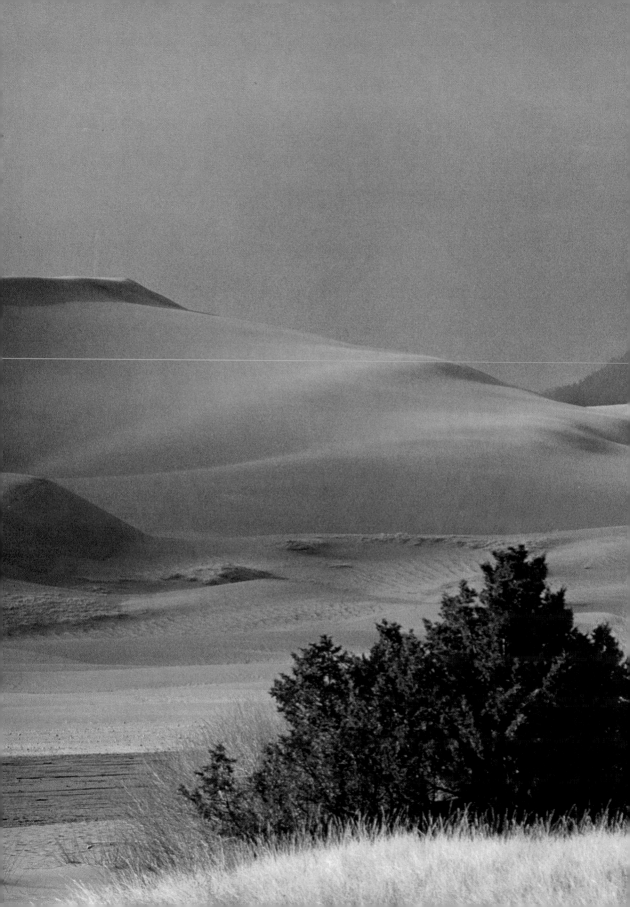

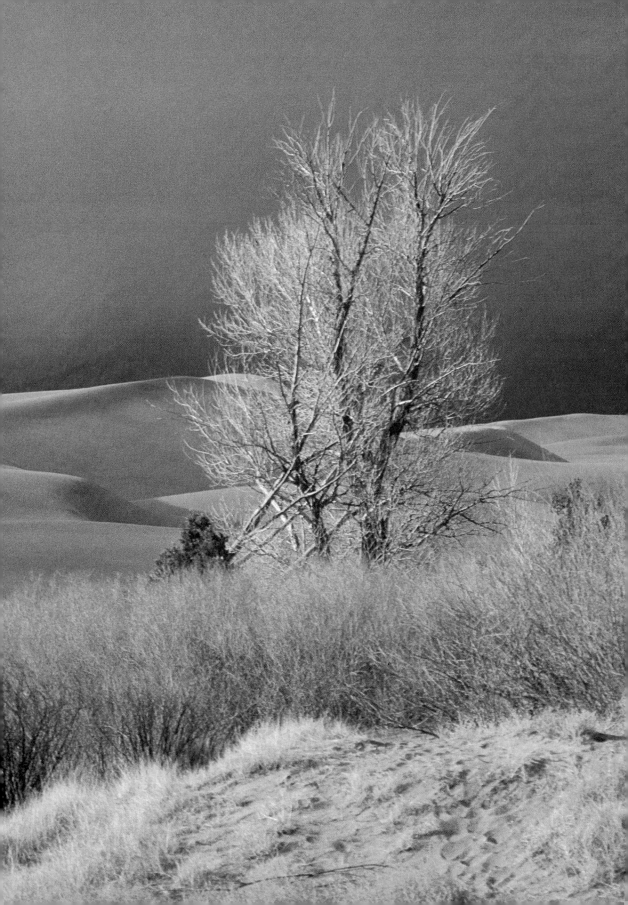

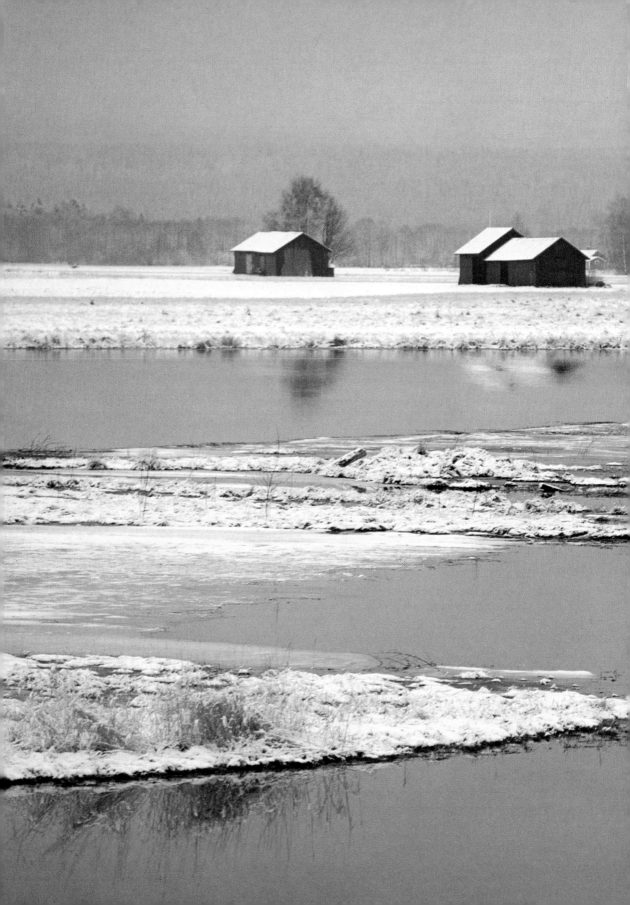

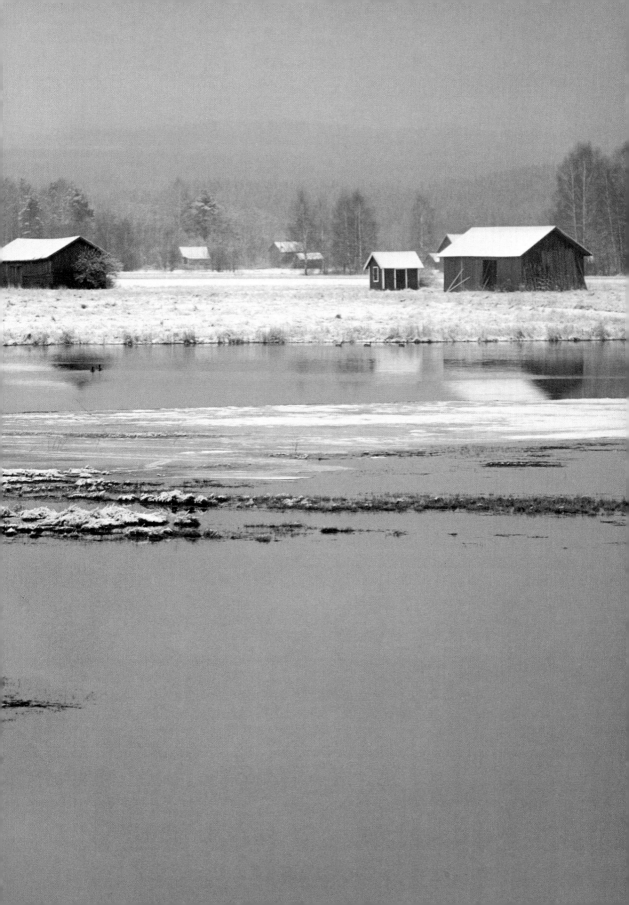

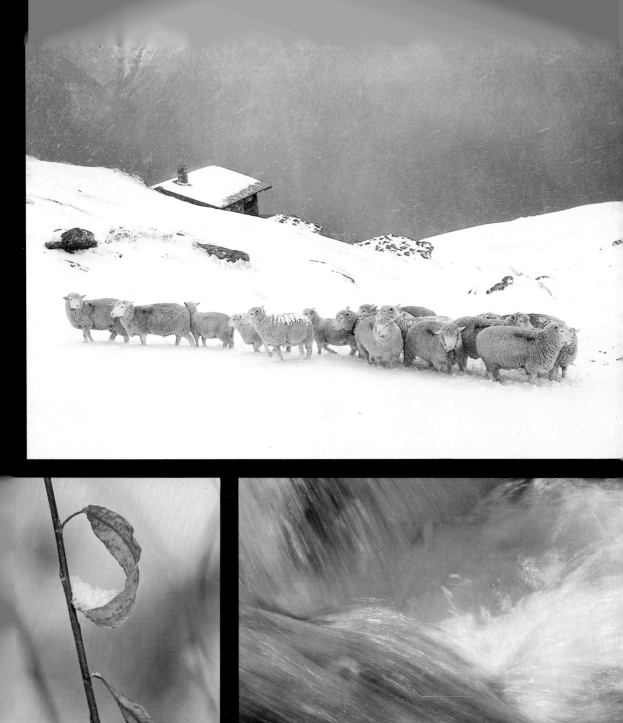

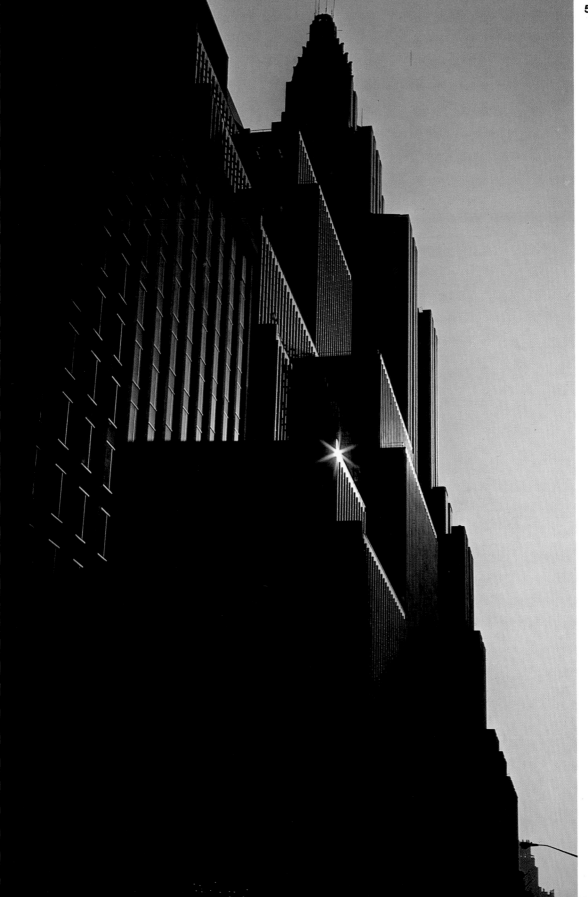

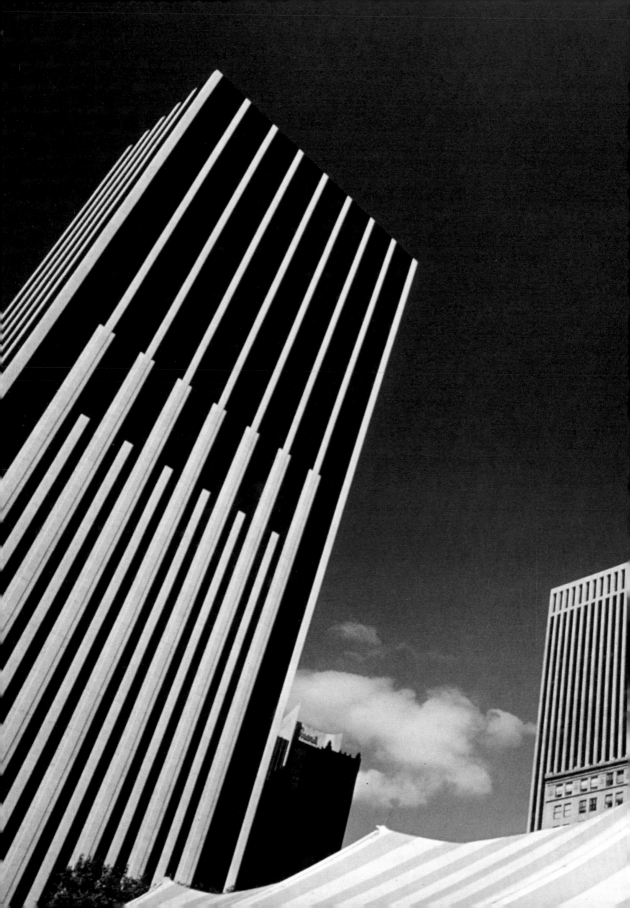

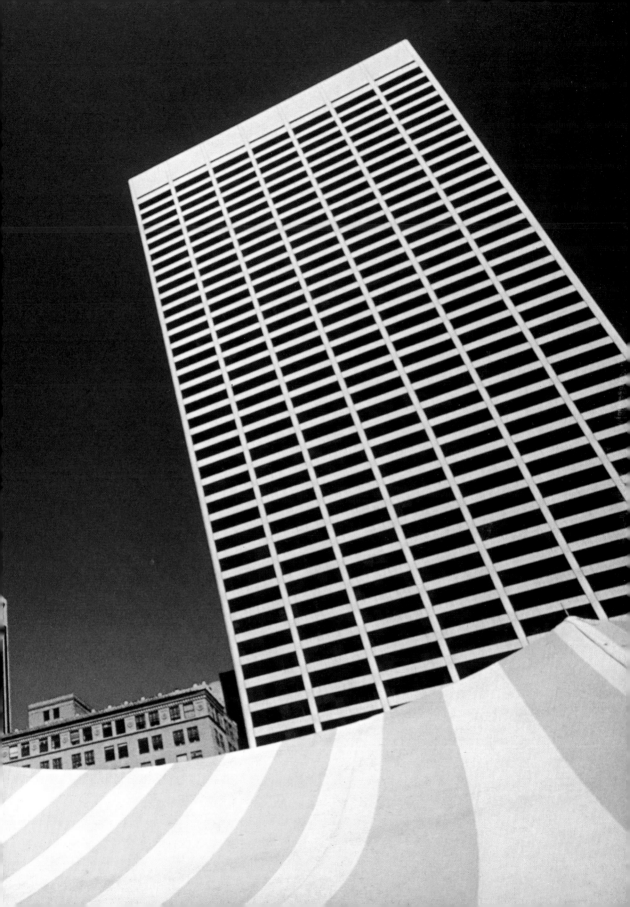

"The World is Beautiful"
nnelore Petermann, Germany
s is a classical motif which was
cted for this book because it is
of the most favorite ones in amateur
tography and a superb one at that.
s goes for the exposure as well as
ign and colour. The monochrome
nposition which hints at the blue
above is pierced by the rays of the
penetrating the morning mist. The
tographer took several shots with
ous exposures because of the con-
tly changing play of light. This
ture was exposed at 1/250 sec. at
2 on Ektachrome (19 DIN) with a
mal 50-mm Summicron-R 1:2
s on a Leicaflex SL.

"Sunset"
Jürgen Neumann, Germany
dscapes, atmospheric phenomena
repeated sunsets are the favourite
mes of the photographer of this
ture which won the first prize in the
up "The World is Beautiful". He
k this photo in Southern France from
Cap de la Chèvre on the Crozon
nsinsula. The blue and somewhat
y sky, the lighthouse which rises
of the sea like the periscope of a
marine and the setting sun inspired
J. Neumann to catch that moment
film. "I quickly mounted my 280-mm
yt lens on my Leica, secured it on a
od and fastened it on a rock. I did
use a filter but exposed slighlty
ter than the exposure meter indicat-
(1/8 sec. at f. 4). The result: a
tle yet very powerful scene.

34 "Gate Through the Clouds"
Konstantin Thiessen, Germany
A good portion of luck is necessary to
photograph a beautiful seascape such
as this one. K. Thiessen reports that
never before in his life had he changed
a lens on his Leica as fast as on that
stormy morning when he discovered
this gate through the clouds. He knew
instantly that swift action was required,
and the only lens capable of rendering
this unique phenomenon was the
35-mm wide-angle lens. Exposure:
1/125 sec. at f. 5.6 on Agfa CT 18.

35 "Dusk"
Helmut Hermann, Germany
This panorama was photographed
during a Sahara expedition from the
9,800-foot-high Mount Assekrems,
the highest mountain in the immense
Hoggar Range. "The last rays of the sun
in a cloudless sky set off the peaks in
finely graded grey hues," writes H.
Hermann who used a 180-mm Elmarit-
R 1:2.8 on his Leicaflex SL. Exposure:
1/250 sec. at f. 4 on Agfacolor CT 18.
The delicate colours and graphic
composition made this photo a prize-
winning entry.

36 "Watchtower on the Shore"
Erich Klemm, Germany
This is the landscape of a prizewinner
and one senses the graphic artist
behind the camera who composes his
pictures with very few colours and clear
lines. A watchtower on one of the
gigantic Canadian lakes in Ontario
inspired him to design this coastal

landscape. The entire colour scheme
consists of grey, blue and a few
brownish-red wooden planks on the
watchtower. This is a strong graphic
composition with the horizontal lines
of water and sky, a pronounced narrow
strip of land dissected by the tower
with its vertical planes and lines and
last but not least the pulsating rhythm
of the reddish-brown ladder rungs.
Tech. data: 28-mm Elmarit-R, 1/30 sec.,
f. 8, Agfachrome 50 S.

37 "Geometry of a Salt Mine"
Werner Köhler, Germany
This picture won third place in the
landscape group. Werner Köhler took
it while on vacation on the island of
Lanzarote. He discovered this motif in
the northeast of the island and was
taken by its pronounced geometrical
elements. This entry was one of many
exposures and the most successful one.
Naturally the photographer was fasci-
nated by the play of colours, the brown-
ish red of the water in the foreground
with clouds mirrored in it, the con-
trasting blue of the sea and the mountains
in the background, the light blue
strip of sky on the upper edge of the
picture and the geometry of the white
gleaming salt heaps in this landscape.
In order to intensify the dynamism
Köhler used the 35-mm Elmarit-R
1:2.8 and exposed 1/125 sec. at f. 8
on Kodachrome 64.

38 "Approaching Thunderstorm"
Jean-Pierre Conrardy, Luxembourg
The Seiseralm affords ever new and

fascinating views to the photographer, especially under lighting conditions such as are caught in this picture. Now and then the sun breaks through a heavy leaden sky and like a floodlight illuminates the spring scenery, the meadows and the mountains, snow-covered from a recent thunderstorm and rising high and mighty on the horizon. Spring in the foreground, winter in the background — this contrast is what "makes" this picture. In order to capture this dramatic landscape in its totality, Conrardy used his 35-mm wide-angle lens (Elmarit-R 1) and exposed 1/125 sec. at f. 8 on Kodachrome 25.

39 "Golden Sun"
Helmut Hermann, Germany
This is a daring picture taken during rising mist in an African jungle landscape. H. Hermann included the sun in his picture which, as everyone knows, creates specific problems in gauging the exposure. The photographer writes that by employing his spot measuring through-the-lens exposure meter he aimed at a medium light area which resulted in a good picture at the first try, as one can see. Under light conditions such as here it is generally advisable to underexpose slightly. H. Hermann set his shutter at 1/125 sec. at f. 4, using a 180-mm Elmarit-R 1 : 2.8 lens (Agfacolor CT 18).

40 "Spring Landscape"
Uvo Pauls, Germany
Sixty percent of the total German rape-seed production is grown in beautiful Schleswig-Holstein. This is where Uvo Pauls took this picture; he had to wait for that specific moment where the sun broke through the clouds and illuminated the scene dramatically from the side. Thus light and shadow in the hilly foreground are graphically delineated and dramatic colour contrasts were achieved between the golden-yellow rape field and the low, cloudy grey-blue sky. Tech. data: Leicaflex SL with 35-mm Elmarit-R 1 : 2.8 lens, 1/250 sec., f. 4, Agfachrome 50 S.

41 "Pair of Willows in Spring"
Helmut Clever, Germany
The eye travels through large delicately coloured patches (poppies) — which dominate the foreground — to two sturdy willows. The sun had already set when the photographer discovered his motif, yet this proved a help rather than a hindrance in this almost monochrome composition because now the reflection of the blue sky "cools down" the finely graded green tones. The 180-mm Elmarit-R again proved an ideal lens for landscape photography. Exposure: 1/500 sec., f. 5.6 (Ektachrome 19 DIN).

42 "Contrasts"
Fred Hoogervorst, Holland
The photographer favours close-ups and especially motifs where he can employ his 60-mm Elmarit-R 1 : 2.8 lens which he used to take these autumn leaves. He prefers backlight which traces the surface of the leaves and delineates the structure of the ribs very delicately. With motifs such as this one only the wind can prove annoying, for at a shutter speed of 1/60 sec. it can result in a blurred picture. In spite of this rather long exposure time the photographer had to use an aperture of f. 4 to avoid underexposing his film (Agfachrome 50 S — 18 DIN).

43 "Piece of Jewellery"
Herbert de Buhr, Germany
The 60-mm Macro-Elmarit-R 1 : 2.8 has proven a universal lens for close-ups. H. de Buhr always takes it along when roving through the city park with his camera in order to photograph flowers, blossoms and leaves. He discovered this "diamond" on a morning walk. The restrained greenish-brown colours and the classical triangle of the leaves reminded him of a piece of jewellery with a precious stone. There was enough light to set the shutter at 1/125 sec. at f. 5.6 on Kodachrome to obtain a suitable depth of field.

44 "Light Reflections"
John W. Bewley, USA
John Bewley took these leaves with a close-up lens on his 50-mm Summicron-R 1 : 2.8. He wanted to catch the unusual light reflections which enliven the picture as blue light zones and the strange contrast to the yellow leaf and bud on the right-hand side. This is a typical motif owing its effectiveness to colour composition, atmosphere and the coloured spots of light rather than

to a precise image. No technical d was submitted.

45 "Pearl on a Great Burnet Lea
Werner Velte, Germany
The "dew drops" visible on the edges of the great burnet in the morn are drops of water which are secre through gland-like water ducts. T phenomenon is called guttation. T explains why the drops seem to sta on the edge of these leaves. The pho grapher used a 100-mm Macro Elr with a bellows unit on his Leicaflex For additional light and greater dept field W. Velte employed the Bra F 655 with an additional lamp. Shut speed: 1/30 sec. at f. 8 on Kodachro 25.

46 "Shimmering Grass"
Luitpold Raith, Germany
The most beautiful and fascinat way to photograph for Luitpold Ra is to crawl through meadows a bushes and discover the microc mos with his Macro Elmarit-R 1-2 : 60 mm lens. He submitted this "port of a blade of grass" to illustrate conviction. While one blade is pictu precisely in focus the rest are discerni only as dots of light reflected in dew drops. Backlight called for 1/2 sec. at f. 2.8 on Kodachrome 64.

47 "Misty Forest"
Gerhard Büttner, Germany
On closer look the viewer will disco that this is a "sandwich", i.e. t superimposed transparencies. G. Bü ner took the scene twice, using a sl shutter speed (1/15 sec.) for the seco exposure and moving the camera fr top to bottom. This is how he achiev the desired slightly blurred effe Tech. data: exposure 1 : 1/60 se f. 5.6; exposure 2: 1/15 sec., f. 8 Ektachrome 19 DIN (with 28-n Elmarit-R lens).

48 "Autumn Sunshine"
Ben Bielski, USA
Father Ben, as he calls himself, is enthusiastic landscape photograph His autumn scene is one of the b entries in the Leica contest becau rarely does one see such colo harmony. Unfortunately Father B submitted no further details to entry. It was evidently taken in so

...ghland. The foreground, dominated ...a green bush, shows the most deli-...e shades of yellow, ochre and ...wn. Tech. data: 135-mm Elmarit-R 1 ...8, 1/125 sec., f. 8, Kodachrome 64.

"Winter over the Hovran"
...gnar Andersson, Sweden
...dersson wanted to illustrate the ...arms of a calm, snow-covered lake ...ndscape on a hazy morning. Every ...tail contributes to the perfection of ...e scene, a beautiful composition ...monochrome blue tones. Narrow ...ips of land and ice, lightly covered ...th snow, spread their fingers across ...e glassy surface of the lake. The ...licate reflections of the huts and the ...ass in the water seem almost painted. ...ch. data: 135-mm Elmarit-R on a ...icaflex SL, 1/125 sec., f. 4, Koda-...rome 25.

"Flock of Sheep in Newly Fallen Snow"
...agda Boll, Germany
...e first snow took this flock of sheep ...the Valais Mountains of Switzer-...d by surprise. Magda Boll discovered ...s scene on a mountain hike. On the ...e hand she was fascinated by this ...enomenon of nature, and on the ...er hand she feared for the sheep, ...ddled frightened in the snow. Her ...ture is symbolic of the desolation, ...d and fear of the animals. Newly ...len snow in the mountains means ...nger for man and beast. Magda Boll ...cceeded in expressing this in her ...ture. Tech. data: 50-mm Leica ...mmicron 1:2, 1/125 sec., f. 2.8, ...dachrome 64.

"A Trace of Snow"
...ribert Dünzl. Germany
...is is a twig of a willow which ...ribert Dünzl discovered on a wintry ...y. He took the picture because he ...s fascinated by the ornamental ...ape of the leaves. The brownish gold ...the wilted leaves seemed ideal for ...lose-up. He needed a complimentary ...lour and found it on focusing on his ...oject—a patch of sky seen through ...e leaves and blurred into a blue blob. ...ribert Dünzl incorporated it as a ...ntral part of his attractive composi-...n. Tech. data: Leica with a bellows ...it and the head of the 200-mm Telyt; ...0 sec., f. 5.6, Kodachrome II.

52 "Water Colours"
Franz Paul, Germany
Not many photographers would con-sider a clear mountain brook an in-triguing motif. Franz Paul noticed the changing colours as a torrential stream rushed over brown, green and yellow boulders. He took this photograph of the Clengia Brook in the Lower Enga-dine. It was not just the colours that intrigued him but also the streaks of light in the gushing water and the sharp outlines of the waves against the light. The photographer decided on a long exposure (1/15 sec. on Koda-chrome 64) and a small aperture (f. 6 with the 135-mm lens) in order to capture the flowing motion contrasted by the foaming water.

53 "Intersecting Paths"
Walter Seipel, Germany
The photographer accomplished this original landscape by using a favourite trick (sandwiching). The thick hoar-frost over the autumn scene and the splendour of the whitened willow against the blue of the sky were not enough for Walter Seipel, so he took several shots of the scene—with and without the man in the picture—and superimposed the almost identical shots (one back to front) so that the paths crossed. Both photos were taken with the 135-mm Elmarit on the Leica. Shutter speed: 1/250 sec. at f. 5.6 on Kodachrome 64 (skylight filter).

54 "Frosty Day"
Helmar Eberwein, Germany
The photographer had to wait a long time on that frosty winter's day at a temperature of 15 degrees below zero until the fog had descended low enough across his motif to give the picture he had in mind. H. Eberwein had already mounted his Leicaflex SL with a 180-mm Elmarit-R on a tripod and was just about to give up when the fog lifted slightly. The sun shed a golden hue across the front of the shed and the branches of the tree, and that was the moment to press the shutter (1/500 sec., f. 4 on Agfacolor CT 18). This entry won 2nd prize in its category.

55 "Snow-Covered Boat"
Inge K. Hermansen, Norway
Every time the photographer crossed the bridge and saw the moored boat

he wondered whether this might not be a motif to add to his slide collection. Then one night snow fell and that decided him. He put a colour film in his camera even though he was aware of the black-and-white tendency of this subject. It was the pronounced formal elements of this scene that caught his fancy. No data was sub-mitted.

56 "Skyline With Reflection"
Harald O. Berting, USA
H. O. Berting photographed this re-flection in Manhattan, on 49th Street at the corner of Madison Avenue. This enthusiastic amateur photographer had walked past this scene time and again without registering it. "Then one day, quite unexpectedly, I discovered it while walking to work one morning. It was a quarter past eight and I took it with my Leicaflex SL and a 90-mm Elmarit-R. I chose my position so that the reflections, which are what make this picture, were reproduced most favourable." Tech. data: 1/125 sec., f. 11, Kodachrome 64.

57 "Skyscraper and Yellow Awning"
Uwe Niehuus, Holland
U. Niehuus was torn between admira-tion and frustration as he ran his eye up these concrete monsters. He took photos from all angles, mostly using a 21-mm Super Angulon-R on his Leicaflex SL—the only lens which enabled him to catch the scene as he saw it: looming massively against the sky. Niehuus, at present a photography student in Essen, saw New York also as a professional challenge and con-sciously tackled difficult subjects. Tech. data: 1/60 sec., f. 16, polarising filter, Peruchrome 19 DIN.

58 "Twilight Zone"
L. S. Tan, Singapore
This picture of the façade of a house is a relatively narrow interpretation of the subject cityscape. Yet this scene which the photographer himself entitled "Twi-light Zone" is a fascinating one. As with most night photographs, this scene was taken at dusk but obviously rather late. Tan used a tripod and a day-light film (Kodachrome 64) with a shutter speed of 30 sec. at f. 8, using a 180-mm Elmarit-R 1:2.8 lens.

Animals—Stalked with the Camera

The photographer who wants to "eavesdrop" with a camera has to remove himself from the scene, for if his presence were to be noticed, the scene would change. For this reason, animal photography calls for a telephoto lens with the greatest possible focal length, so that the pictures can be taken from outside the scene. A photographer with only a normal lens fitted to his camera is hardly likely to go on a photo-safari in Africa or join the hunter on his stand. His hunting ground is of necessity somewhat smaller: he takes his photographs at the zoo or at home. Zoo animals, cats, dogs and other pets are easy prey for the photo-hunter with simple equipment. And yet even here there are limits to his scope, because a photograph of a cat such as picture 64 requires a telephoto lens (135-(135-mm). Why? It's a matter of getting as close to the animal as possible without putting it to flight, and bridging the remaining distance with a telephoto lens. As this distance is different for each animal, it requires enormous patience and a certain experience with animals. Fantastic photographic equipment and the wish to photograph animals are just not enough. The photographer who is not prepared to show consideration for their habits and behaviour will not be very lucky, and luck is a necessary ingredient for success. In no other branch of photography does fortune reward one's efforts so favourably as in animal photography. Animal photographers play chess with nature's creatures, and only those who are patient enough to play until checkmate can achieve masterpieces with the camera.

In principle there are two approaches in animal photography. The first is concerned simply with documentary presentation, the second attempts to capture specific behavioural characteristics such as leaping or flying. Both have their merits but action photos—i.e. capturing the characteristic wing movements of a bird, the lioness stalking up on her prey, or the fleeing of an antelope—are the acme of animal photography. They are created in the wild and require a considerable amount of time, technique, film equipment and, as always, patience. And so it is not surprising that the best photos on the following pages were taken by animal photographers in the true sense of the word, people whose professions bring them into contact with animals either as biologists, zoologists or geographers.

This keen fundamental interest in the animal itself is the determinant motivation. It is equally rewarding for the pure amateur who takes an interest in animals; after all it doesn't have to be wild-life subjects. The domestic cat, dove, even a toad are all animals which everybody comes across (pictures 64 to 66). Yet even with these animals one shouldn't settle for a simple static reproduction. Good photos in this field depend on the originality of the scene, on a certain comic element in the situation in which the animal has been photographed. The portrait of the toad would probably find little interest were it not for the fact that it sat in the pouring rain (clearly visible), that the photographer lying on his stomach took it in this strange position and against the light. Light reflections bring the picture to life, the static becomes alive.

The most suitable training ground for potential animal photographers is the zoo. The novice can practise specific techniques and his psychological approach to animals without having to invest too much patience and time; nevertheless it is seldom possible to take dynamic animal photos there, as a caged animal can rarely be seen leaping, in ecstasy or fighting with his fellow species. Good animal pictures taken in zoos are more likely to be humorous (e.g. 67 and 69) and it is precisely the funny scenes from the animal world that editors select for publishing and that frequently achieve success in competitions.

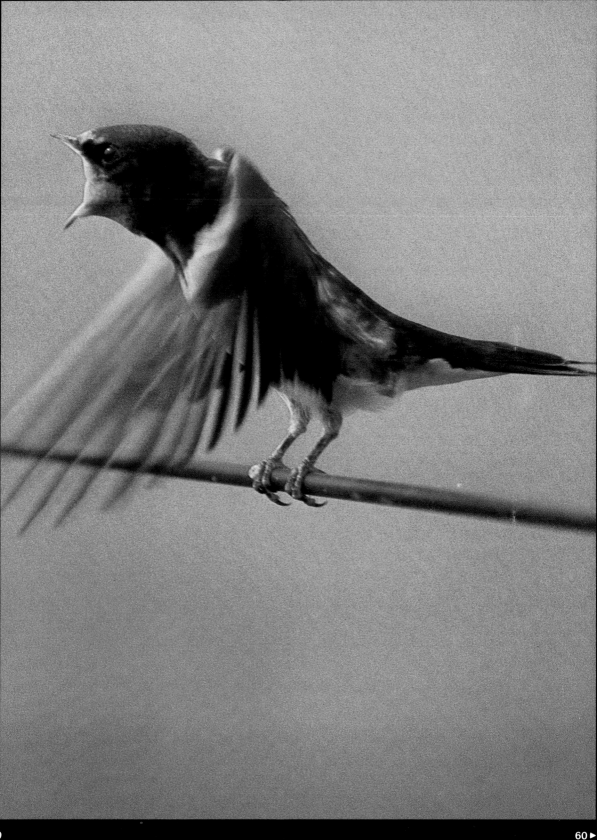

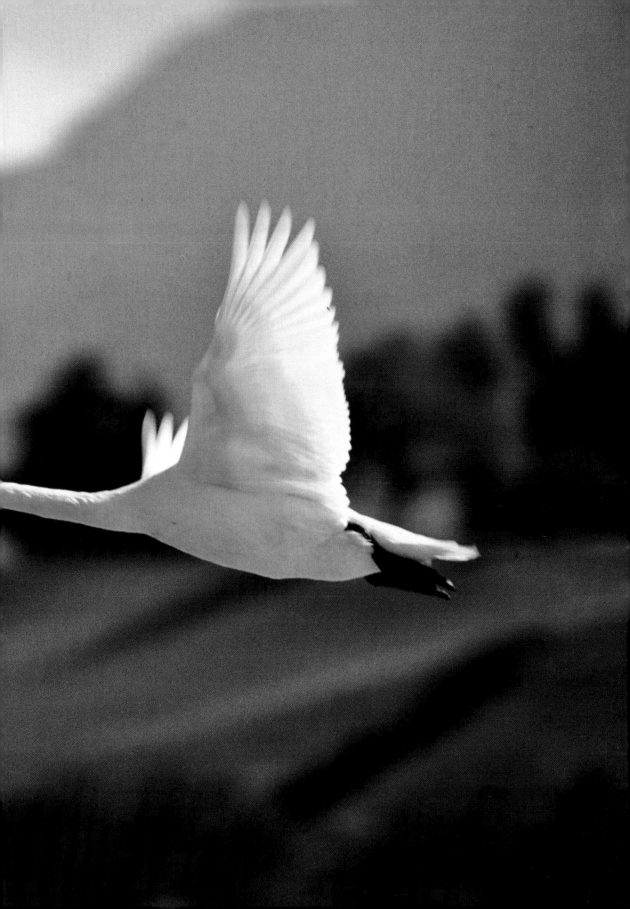

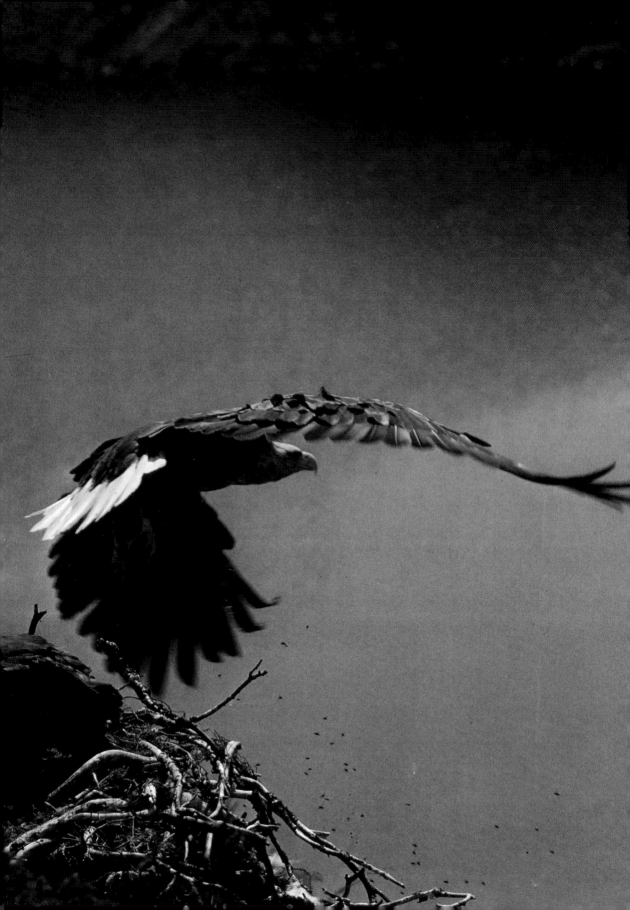

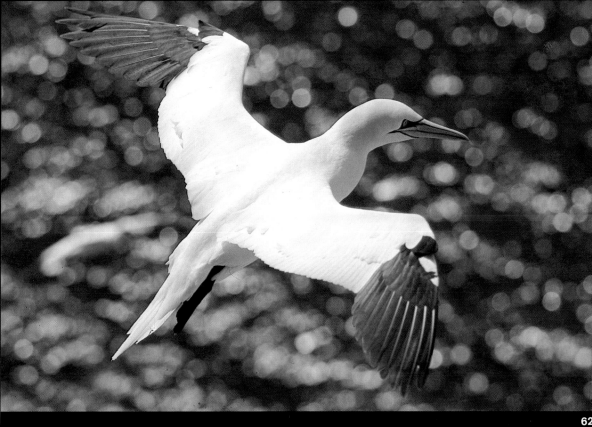

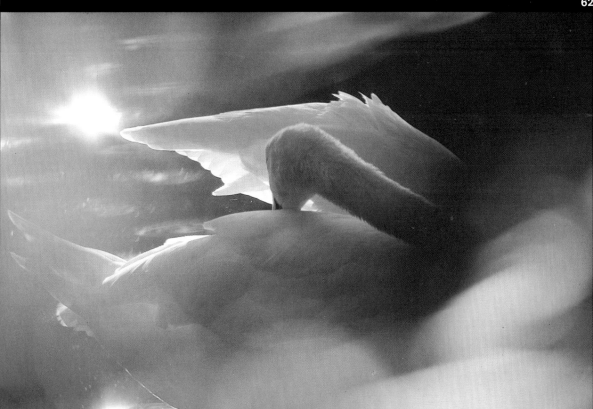

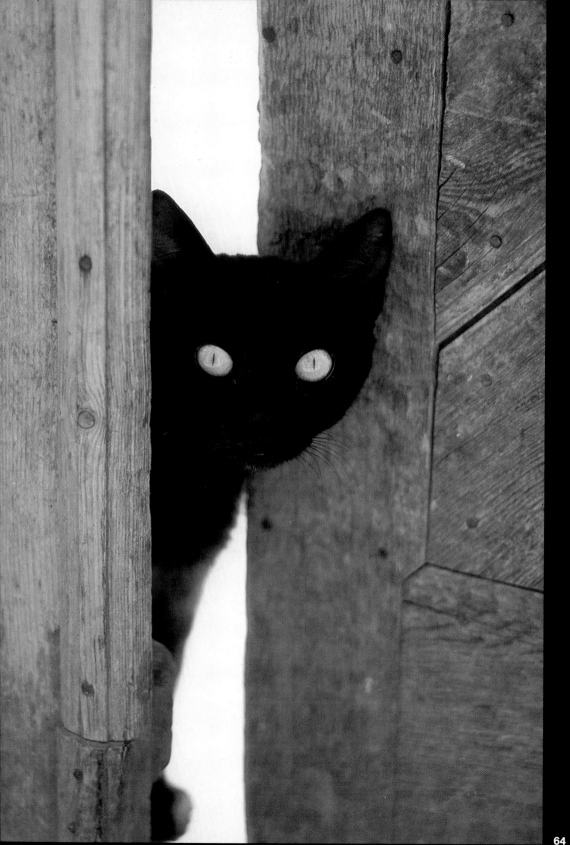

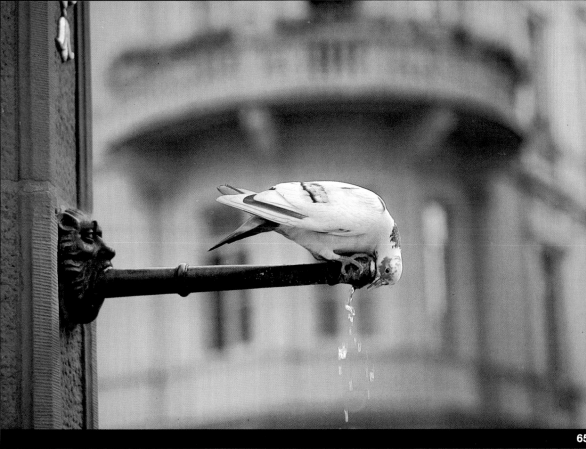

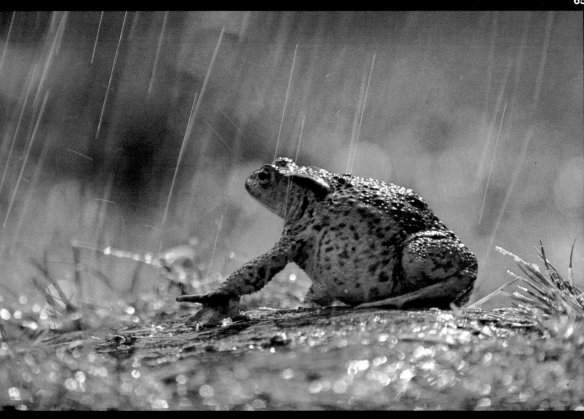

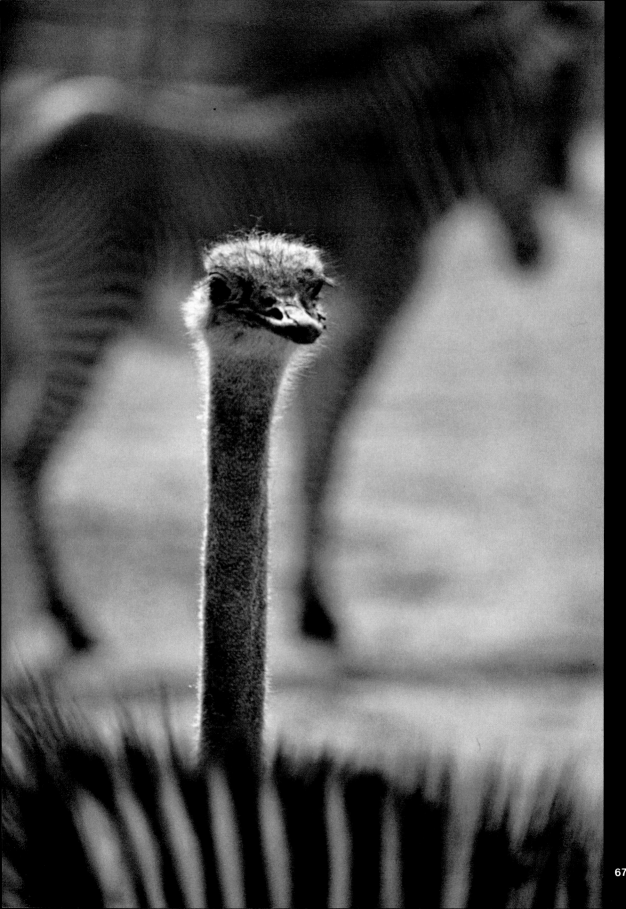

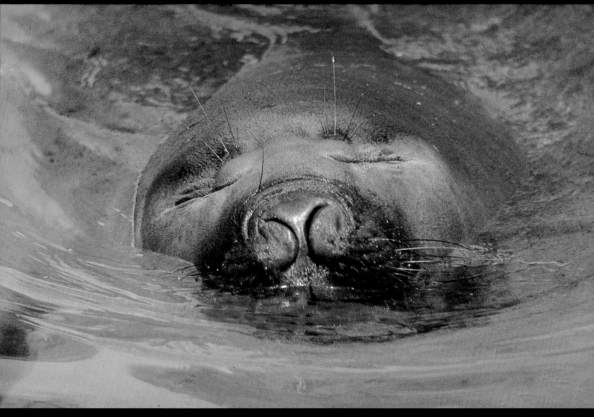

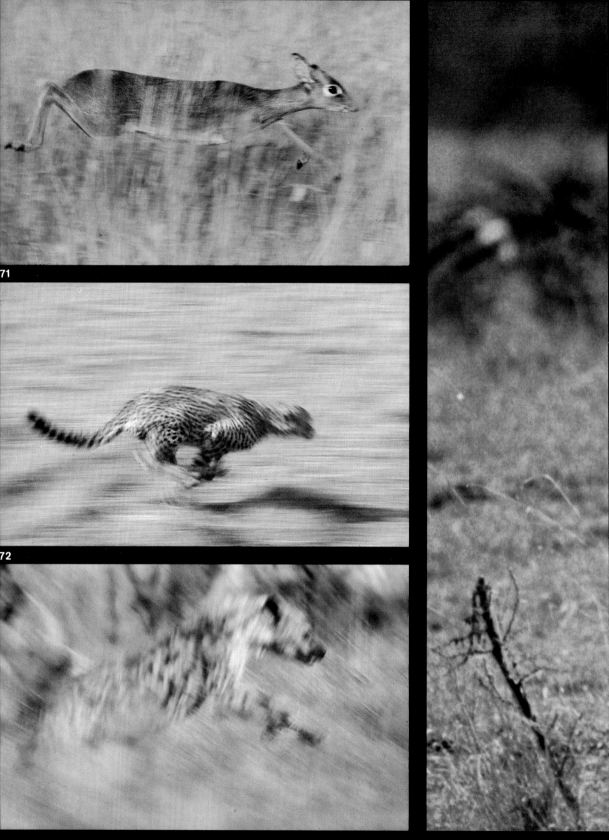

71

72

73 74

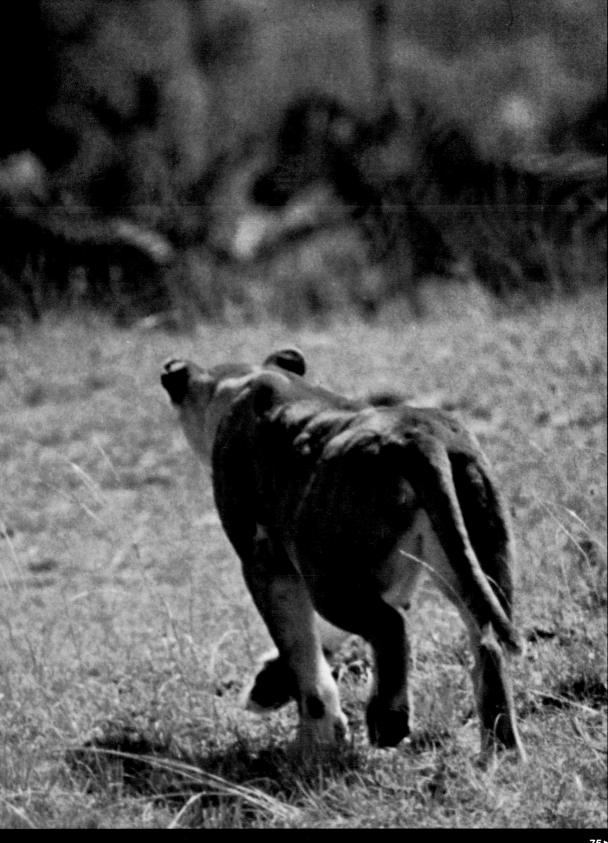

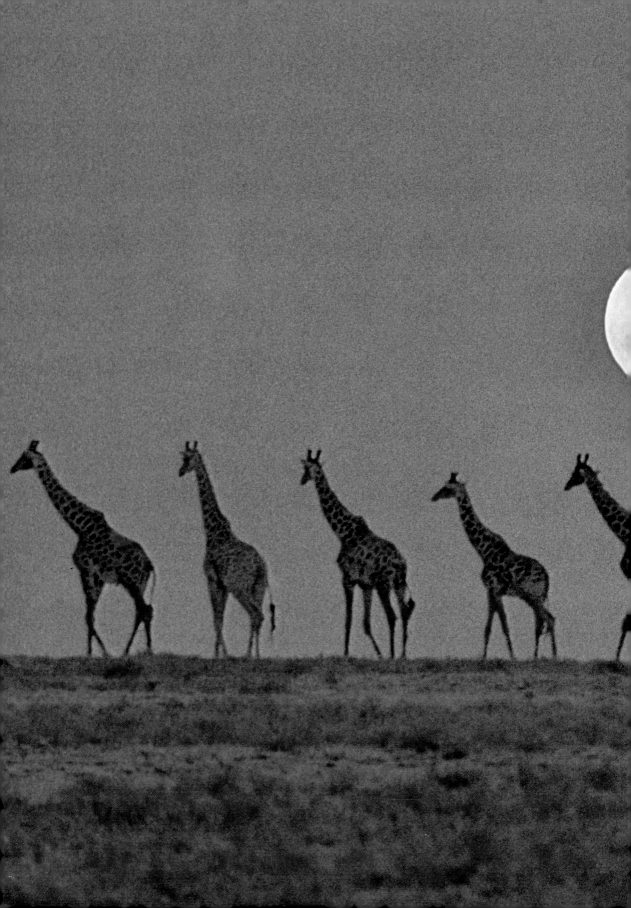

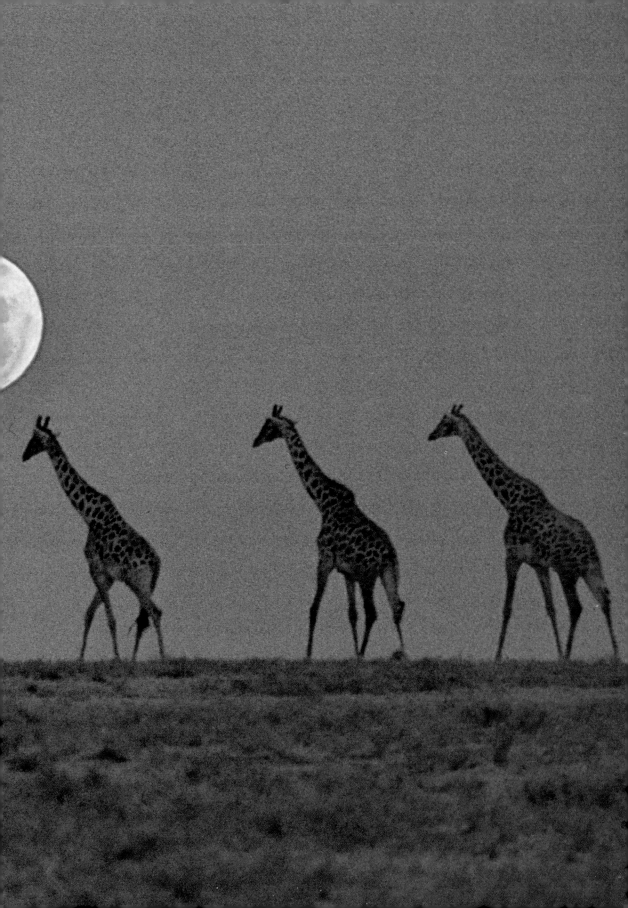

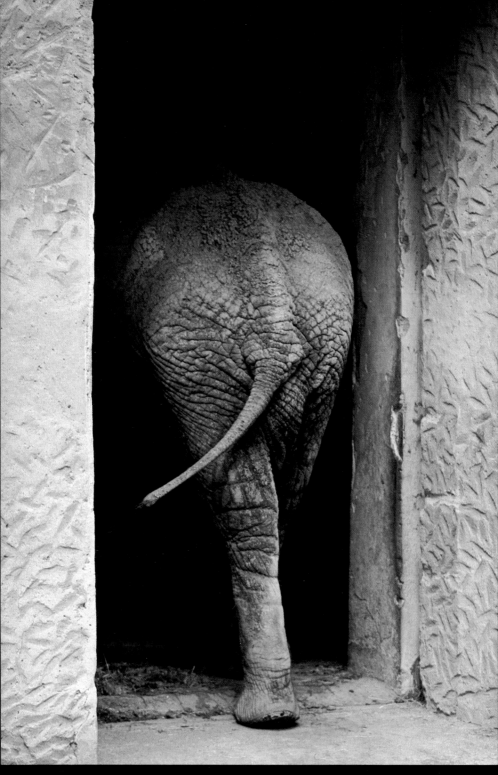

"Protesting Swallow"
mi Surmont, Belgium
aybe it is the ever-present hunger
hich this swallow proclaims in an
gry cry from his telegraph wire, or
rhaps it is caused by fear. In any
se, this picture did not simply fall
to the photographer's lap, as it were,
it is the last exposure of a whole
ries of shots. Surmont, a teacher and
ateur photographer, took great care
submerge the background (a farm-
use) into an unrecognisable blur.
e achieved this with a 400-mm Telyt
his Leica to such an extent that the
ckground dissolved into one homo-
nous colour zone. The relatively long
posure (1/125 sec.), f. 5.6 on Agfa-
lor CT 18) was not only called for
cause of the light conditions but
oved an added boon by blurring the
ng tips of the swallow, an effect
hich illustrates the bird's vexation
uch more graphically than completely
arp focus would have done.

"A Mute Swan in Flight"
aus Robin, Switzerland
arely does one see such a perfect
apshot and K. Robin was quite
htly awarded 2nd prize in this cate-
ry with his mute swan. It is difficult
decide what merits more admiration:
e brilliant rendition of the flight
aracteristics, the ideal placement of
e swan in the photo or the perfect
mposition with its softly drawn
pine landscape in the background.
actual fact Klaus Robin, a professional
ologist from Uznach, was out for
ndpipers and had mounted his
icaflex with a telephoto lens on a
onopod in order to be as flexible as
ssible. Suddenly the swans appeared

and flew past very closely. One of the
swans separated from a group of four
and flew directly towards the camera,
only to veer off again at the last moment.
This was the moment to land this
superb shot. Tech. data: 1/500 sec.,
f. 8, Kodachrome 64.

61 "White-Tailed Eagle"
Frank Willie, Denmark
The photographer, a biology student,
participated in two expeditions of the
World Wildlife Foundation to Norway
and Greenland in order to study the
white-tailed eagle (haliaetus albicilla).
In 1975 he returned on his own to the
breeding places discovered during that
expedition in order to take photo-
graphs. He needed a lot of patience
before he got this shot, because nothing
is more difficult than photographing
an eagle on its nest. This photo is one
of the series he finally took. Frank Willie
photographed from a hide in which he
had lain waiting patiently for many
days. He used his Leicaflex SL-Mot
with a tandem device and a 250-mm
Telyt-R 1:4 lens for this picture.
Exposure: 1/500 sec., f. 5.6 on Koda-
chrome 64.

62 "Sula Bassana"
Günther Kipp, Germany
The Northern Gannet is one of the
largest sea birds. With a wing span of
1.80 m it cannot escape one's notice,
but it is a rare visitor to the North
Atlantic. Günther Kipp photographed
this one on the Bass Rocks, a rocky
island 5 kilometres off the coast of
Scotland. On the day this photo was
shot, the photographer had taken up
a position in a niche in the rocks and
when the birds flew past he captured

one of those beautiful birds on film.
While moving the camera to keep the
bird in the viewfinder he swiftly pressed
the shutter. The result is this sharply
focused picture of a bird against a
carpet of blurred circles of light created
by the shimmering sea. Tech. data:
250-mm Telyt-R on a Leicaflex SL,
1/1000 sec., f. 4, Kodachrome 64.

63 "Swan Lake"
Kees van den Berg, Holland
"My aim was to get a picture of a swan
which would reflect the elegance,
grace and a certain narcissism inherent
in these animals" writes the photo-
grapher. It was evening and the sun
approached the horizon when Kees
van den Berg discovered the swan right
in front of his eyes, between sun and
camera. The last rays of the sun were
reflected in the water and shimmered
through the leaves in the foreground.
He watched the swan through his
400-mm Telyt-R lens until the animal
and the glimmering surroundings filled
the viewfinder. Note how the wings
and neck of the swan rise toward the
light from the dark zone of this picture.
Tech. data: 1/125 sec., f. 8, Koda-
chrome 64.

64 "Portrait of a Cat"
Julius Motal, USA
Portraits of cats are favourite contest
entries because they are considered
especially successful. Yet when the
photographer does not demonstrate
a special approach, cats are rejected
by many jury members. Not so this
colour portrait by Julius Motal who
was awarded a certificate for this entry.
Here we are dealing with a superb
snapshot. It shows this black beauty in

a typical situation: waiting in ambush in the chink of the door. We can see that the photographer had to lie on the floor in order to get the lens on eye level with the cat. He only had a split second to act in order to capture this moment on film with the use of a 135-mm Elmarit-R lens. Shutter speed: 1/250 sec. at f. 2.8 an Agfachrome 50 S.

65 "Thirsty Pigeon"
Georg Mann, Germany
This motif called for colour. A white pigeon drinking from a spout stands out sharply against a washed-out background in soft green and red hues. It looks as if the green in the background were reflected on the white body. The red beak and claw add a touch of strong colour to the pastel-shaded composition. The sand-coloured fountain base with its shimmering gold ornamentation is the dominating formal element in this scene. A classical composition with asymmetrical arrangement of horizontal and vertical lines and planes illustrates the clever use of space. Tech. data: 135-mm Elmarit-R 1:2.8 on a Leicaflex SL-Mot, 1/250 sec., f. 4, Kodachrome 25.

66 "Waiting in the Rain"
Anders Lindmark, Sweden
Evidently the photographer had to lie flat in the dirt in order to take this snapshot. Anders Lindmark discovered this toad, which he describes as extraordinarily big, near his country house. It was in no hurry at all. And why, after all, since it rained? And so the photographer, a banking official from Saltsjöbaden, was able to take a whole series of good shots. The best is this one, taken with a 400-mm Telyt-R lens which he rested on a slippery wet grassy knoll to steady his hand. The pouring rain produced bright streaks and shiny reflections on the grass and enhance the atmosphere of this picture. "I never thought of taking care of my equipment," Lindmark wrote. He left the scene of action soaking wet and with a dripping camera. Tech. data: 400-mm Telyt-R, 1/60 sec., f. 8, Kodachrome 25.

67 "Portrait of an Ostrich"
Johannes Pötzsch, Germany
It takes some patience to get a perfect shot of the curious head of an ostrich

like this one by Johannes Pötzsch. It merits careful study. Head and neck are placed precisely between two zebras. The mane of one of them is visible in the foreground, while the other is softly silhouetted in the background. Only the use of a 400-mm Telyt-R lens enabled J. Pötzsch to achieve such division of foreground, centre and background into three focal planes. Tech. data: 1/125 sec., f. 6.8, Agfachrome 50 S.

68 "In the Pool"
Reinhard H. Grefen, Germany
The photo club to which R. H. Grefen belongs had set its members a theme: movement: So this amateur photographer headed for the zoo in order to interpret the theme. He decided to employ this blurred technique because it suggests movement and is particularly effective in illustrating how the polar bear shakes the water off its body, as one can see in this photo. The photographer wanted to counterbalance the blurred zone and decided to picture the nose in focus, since it is that part of the body which moves least while shaking. Use of a normal lens (150-mm Summicron 1:2) for such shots is unusual, since the photographer has to get very close to the animal if he wants to fill his viewfinder. Usually a telephoto (90 mm or 135 mm) will do the trick. Tech. data: 1/15 sec., f. 16, Kodachrome 64.

69 "Siesta"
Thomas Wandelt, Germany
The photographer followed the sea lion a full hour before he got it into his viewfinder like this. Despite the slowness of its movements he could not get a good head-on view because of the erratic movements of the animals. Endless patience and continuous refocusing were finally rewarded. Of course this is not exactly a new motif, but rarely does one see such a droll expression on the face of such an animal. The photographer had focused precisely on its whiskers, using a 280-mm Telyt on his Leica — a reliable lens which is easily set. Tech. data: 1/500 sec., f. 4, Agfacolor CT 18.

70 "Iceland Ponies"
Gudmundur Ingolfsson, Iceland
The photographer from Reykjavik sub-

mitted us a motif typical for his count Iceland ponies. Obviously the you girl in her yellow oilskin is in her elem among these animals, as one can from her radiant face. G. Ingolfss was charmed by this scene: a spot golden yellow, a violet-coloured sc among the brown and black backs the ponies. With a 90-mm Elmarit le he was able to place the girl right in center of this photo — but not witho difficulty, since he was on horseba In spite of his awkward position he p duced a striking picture full of atmo phere, a characteristic scene of eve day life in Iceland. Tech. data: 1/2 sec., f. 5.6, Ektachrome X.

71 "Dik-Dik"
Reinhard Künkel, Germany
R. Künkel is a successful animal pho grapher and it is to his credit that describes his entry as a lucky sna shot. This is what he says: "I h watched a pair of dik-diks — smallest representative of the antelo family — for several days. One aft noon I had taken a few portraits these animals when some noise frigh ened them and they fled, including t animal standing closest to me. made off in huge leaps and as a refl I pressed my shutter." Künkel usua photographs without a tripod ev when using the long 400-mm le He sets the shutter usually at 1/250 se sometimes at 1/125. The picture of t dik-dik was shot with the SL Mot 1/250 sec., f. 6.8 and a Telyt 400-mm lens on high speed Ekt chrome.

72 "Fleeing Cheetah"
Dr. Georg Rüppell, Germany
An impression of speed can be render on a still photograph by following t subject with the camera. The phot grapher who submitted this entry is successful zoologist and the author a magnificent book on the flight birds. The photo of this fleeing cheet was also taken while panning t camera. Dr. Rüppell set it at 1/30 se f. 11, using a 50-mm Summicron-lens (Agfacolor CT 18). The cheet shows varying degrees of blurrir according to the various speeds of th various parts of the body. Backlig added contrast and silhouetted t animal better against the backgrour

"Leaping Hyena"
gen Gottschick, Germany

e photographer does not remember
cise technical data of this picture
ept that he used a 400-mm Telyt-R
s and a Peruchrome (19 DIN) film.
dging by the degree of blurring the
tter speed might have been 1/30 sec.
onger. In any case this picture is an
cellent rendition of the moment
en this hyena in the Krüger National
k in South Africa almost virtually
into the photographer who instantly
k a shot with his camera. Not only
hnical know-how but a portion of
k is needed in order to come up
h such an impressive photo. The
otographer quite correctly describes
entry as follows: "The scene is full
drama and dynamism and its colour
dition is excellent."

"Attacking Lioness"
lter Spiegel, Germany

Spiegel shot a whole series of the
ion which followed this picture.
e lioness is hunting one of the ze-
s passing in the background and a
moment later sank her teeth into her
prey. Yet he considers this photo of the
lioness creeping up on her victim the
most dramatic shot. He noticed the
animal from his car on the border
between Kenya and Tanzania and
followed it. He happened to have his
90-mm Elmarit-R lens on his camera
and one can see how closely he had to
get to the lioness to take this picture.
The photographer makes no mention
of fear in his letter but of hyenas and
vultures which later descended upon
the zebra and devoured it. Tech. data:
1/25 sec., f. 5.6, Kodachrome 25.

75 "Giraffes in Full Moon"
Reinhard Künkel, Germany

Every photographer's dream of the
ideal shot is here come true: a line of
giraffes parading in a violet desert night
under a shiny moon. The photographer
had previously experienced such scenes
without ever being able to record one
on film. So he used a trick: he made
two exposures—one of a herd of
giraffes walking along the horizon and
one of the moon, then he superimposed
the two pictures which he had taken
with a 400-mm Telyt-R lens on his
Leicaflex SL. He did this very skill-
fully, and the scene looks so natural
that even experienced animal photo-
graphers would take it for a genuine
dream shot. Reinhard Künkel conse-
quently received a prize in this group.

76 "The Other Side of the Coin"
Paul Gluske, Germany

This snapshot is also a prize-winning
entry. Paul Gluske shows how imagina-
tion can lead to an original photo even
on days where luck is less forthcoming.
Yet no amount of imagination or plan-
ning is any good if the animal in the
viewfinder refuses to cooperate. Our
photographer was lucky, though, as
far as the animal was concerned, which
is not to say that he got his shot at
first try. Some patience and a good eye
were called for and Paul Gluske had
both, and artistic talent on top. This
graphic shot of an elephant's posterior
proves it Tech.data:180-mm Elmarit-R
on a Leicaflex SL,1/250sec., f. 2.8,
Kodachrome 64.

itor's Note:

us Paysan, the well-known animal
d nature photographer, regards the
ular contention that pure science
. scientific animal photography) is
ompatible with aesthetic merit or
neral public appeal as an old wive's
e. He supports his view with nume-
s practical examples in his book
nature photography—one of the
v books in which a successful animal
otographer reveals the secret of
ny years of professional experience.
selecting animal photos for this
ok we did not observe any scientific
eria but judged them on photo-
phic and aesthetic merits alone. The
tifs on these pages serve primarily
an example of how to approach
a given subject artistically. We are
convinced that they serve as proof that
animal photography gains in authenti-
city and dynamism the more the photo-
grapher succeeds in capturing a be-
havioural characteristic typical of the
species. The live portrait of a young
swallow (picture no. 59) is a perfect
example of how the man on the street
equipped with a telephoto lens on his
camera can produce a picture full of
expressiveness and drama. The fact
that the photographer also produced a
masterly example of perfect composi-
tion considerably heightens the psy-
chological impact of the purely photo-
graphic content. It also illustrates how
even the beginner should think about
artistic approach when starting out in
animal photography, especially when
taking pictures of animals that virtually
live just outside the door. Although the
newcomer might consider himself
lucky on merely catching a fluttering
bird right in his viewfinder, he will soon
learn how to follow the bird's flight
with his camera and press the shutter
at the right moment. Animal photo-
graphy, as far as most publications on
colour photography are concerned, is
still a rather neglected branch, and the
aspiring photographer interested in the
immense progress made in this field
does well to consult the relevant zoolo-
gical books when looking for examples
of dynamic animal photography.

Sports Photography — Documentary Record or Impression

What exactly is a photographically created impression? It is a kind of representation related to the Impressionist school of painting involving the dissolving of things into blurred shapes and colours, which was practised and publicized by well-known sports photographers such as Erich Baumann, Horst H. Baumann and Rupert Leser. The advance of colour into sports photography in particular made this out-of-focus technique of capturing motion more and more popular. Nowadays there is hardly a notable sports photographer who does not master this technique. Sports impressions are particularly popular in illustrated souvenir editions of the World Cup or the Olympic Games for instance. They are always given preference by editors and publishers when looking for a photo depicting the atmosphere of a sport, or an artistic interpretation of an event. The actual sports event is coloured by the photographer's personal attitude. Newspaper editors and sports journalists still prefer purely documentary representation which gives a "real" picture (i.e. in sharp focus) of the sports event: the winner must be recognisable, with all associated details.

For the amateur photographer who takes pictures for his own pleasure and for photography's own sake, the out-of-focus technique can be strongly recommended. He can develop individuality better with this technique than with precise images — which is not to say that there is no fun in taking pictures in perfect focus such as 77 and 85 (1/1,000 or 1/500 seconds). In principle the amateur and the professional will have the same approach and will use either technique depending on the purpose of the photograph.

The relationship between an individual and sports in general and his experience in a particular sport are determinant factors in photographic success. Most great sports reporters were once active sportsmen themselves and their sports usually remains their special field throughout their career. This is understandable as one knows the specific characteristic movements of a sport best if one has practised it oneself, maybe even for years. However, other enthusiastic amateur sports photographers can be just as successful on the edge of the pitch or the cinder track. Nor is it true that sports photography is open only to the professional with an official permit to cover the event. Throughout the country there are plenty of sports events offering everybody a chance with the camera.

As in animal photography, the problem of camera equipment must be discussed here. The photographer who aims higher than the average snapshot cannot do without interchangeable lenses. A telephoto lens between 90 mm and 400 mm facilitates the work of the photographer in this field considerably, because the subject can be brought nearer as with binoculars. The picture should concentrate on a single athlete or a group of players who should ideally fill the viewfinder. Another advantage of a long focal lenght is that the subject can be isolated from a cluttered background which is deliberately blurred by limiting the depth of field. The longer the telephoto lens, the easier it is to work with a restricted depth of field. In view of the high standard of sports photography nowadays it no longer suffices to take mere snaps at sports events.

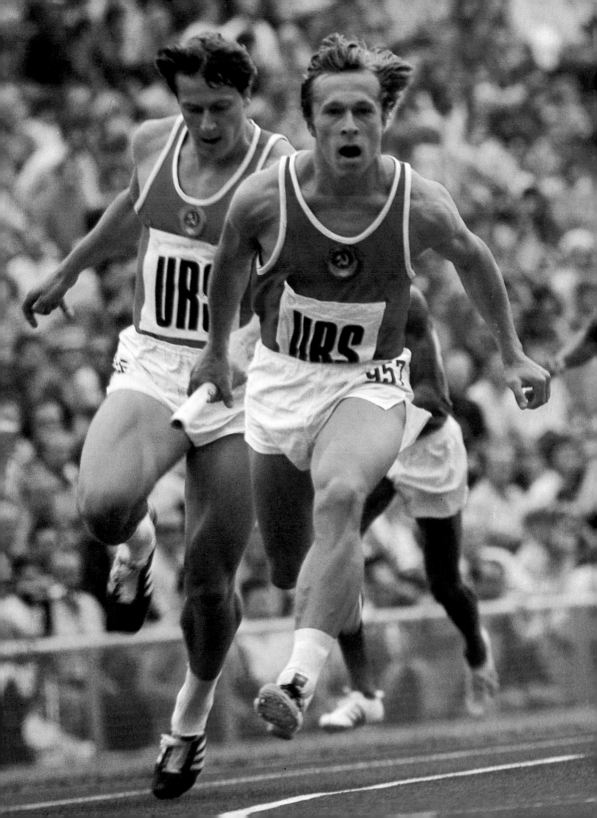

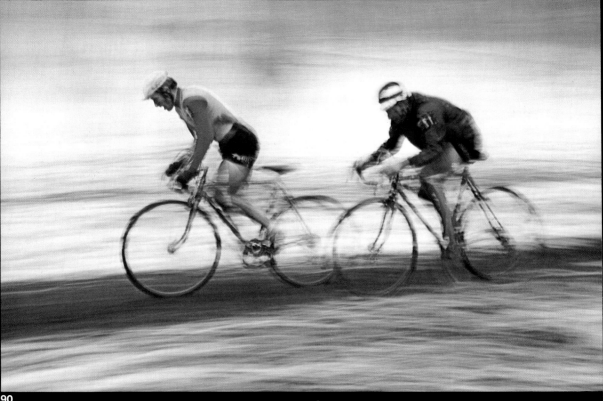

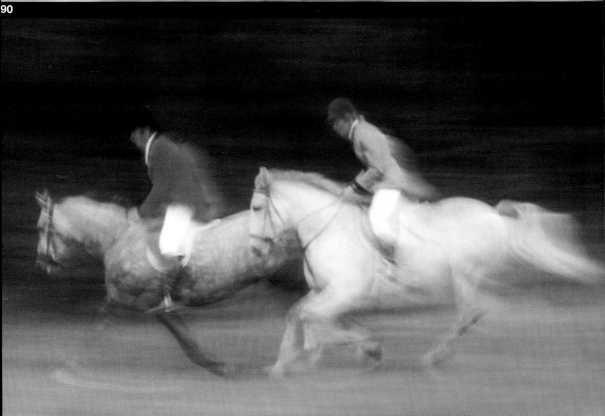

ports—Commentaries and Analyses

"Relay Race"
Georg Mann, Germany
ssing the baton during a realy race
captured here in a breathtaking
ene. Both sprinters—Soviet sports-
en—virtually float in the air while
e baton passes from one hand into
e other. One can tell from the faces
no is at the end and who at the start
his sprint: the face of the first
rinter expresses concentration and
ndled energy, while the other reflects
ief and relaxation. Georg Mann
ught all of this in a split second in
s masterly shot. He used a 180-mm
narit-R lens on his Leica and
posed 1/1000 sec. at f. 4 on
dachrome 64. His entry was awarded
n place in the snapshot category.

"High Jump on Wheels"
enri Gehlen, Luxembourg
ng experience proves that optimal
nditions for the amateur photo-
apher are most likely to exist during
ining in motocross events. Henri
ehlen, who won 3rd prize with his
try, photographed under such con-
ions and he was able to post him-
f with his photo equipment in an
vantageous spot. He watched the
torcyclists for a while and the
cided upon three participants who
uck him for their particularly comical
yle in jumping. He shot a whole
ries of those three. Unusual in the
e he submitted is the rear view
nich the photographer chose for
originality. Obviously the rider had

difficulty balancing. With the help of
a 400-mm Telyt-R lens H. Gehlen
had no difficulty in submerging the
background in an indistinct blur. Tech.
data: 1/500 sec., f. 8, Kodachrome 64.

79 "Submerged in Spray"
Ho Pak Kao, Hong Kong
There is a lot of discussion about
shutter speeds when panning the
camera in sports photography. Yet
there is no clear-cut answer to this
question. Only practical experience in
the sports stadium or along a racetrack
can help. Naturally one must know that
the degree of blurredness depends on
the speed of the moving object and
how it relates to the chosen focus
and shutter speed. The distance from
the object, angle and the steady hand
of the photographer play an equally
important role. There are those who
swear by a tripod and others who find
free-hand more individual and reliable.
The tripod is preferable where the
prefocused point is least likely to alter.
In all other cases it is advisable to shoot
free-hand (as Ho Pak Kao did), so
that one can quickly change position
if necessary. Ho Pak Kao's exposure
while panning the camera was 1/30
sec. at f. 2.8 on Kodachrome 64,
using a 90-mm Elmarit-C on his Leica.

80 "Hell Riders"
Hans Biecker, Germany
The photographer quite rightly main-
tains that luck is as necessary as

technical know-how to come up with
a shot such as this one. It was only
luck, for instance, that the heads of
these two hell riders were passing
through a patch of golden light and
are set out magnificently against the
blurred background. In fact the bushes
on the edge of a wood proved an
ideally structured background. Blurred,
its bizarre shapes intensify the feeling
of speed (compared to picture no. 79
where the opposite effect is achieved).
Like Ho Pak Kao, Hans Biecker set
his shutter at 1/30 sec. with an aper-
ture of f. 5.6 (Kodachrome) although
he used a different lens (28-mm
Elmarit-R 1:2.8). He stood right at
the edge of the racetrack and only
succeeded in getting the whole motor-
cycle in his viewfinder by using this
extremely wide-angle lens.

81 "Air Combat"
Low Chen Khoon, Malaysia
Perfect composition and approach is
rare in snapshots like this one. One
may assume, however, that a certain
amount of direction was at play in
Khoon's picture, but the way he has
captured the absolute climax of the
movement (a sudden leap) is never-
theless admirable. He photographed
from below so that both karate fighters
are set simply against a radiant blue
sky. A few blurred zones around the
left foot of the man in the air indicate
that for a picture of this kind a relatively
long exposure time (1/125 sec. at
f. 8, Kodachrome 64) was used.

82 "Leap Over the Abyss"

Dölf Reist, Switzerland

A terrifying abyss yawns between the two rocky pinnacles. The leap across calls for courage and strenght. Dölf Reist, himself an experienced mountaineer, photographed his friend Ernst Reiss several times on such occasions. Yet the picture he sent us is his most dynamic, most beautiful one, he says. It is indeed a perfect snapshot which catches the leaping man at the moment where he leaps forward with all his might. Another striking element in this picture: the man stretching upward continues the sweeping upward line of the rock, thus creating a diagonal which the rock opposite follows in a parallel line. The pinnacle jutting bizarrely into the blue sky creates a counterbalancing movement. Reist used a Leica and a 135-mm Elmarit and exposed 1/250 sec. at f. 5.6 on Kodachrome 64.

83 "Sailing in the Evening Breeze"

Werner Schäfer, Germany

This photo captures the whole beauty of sailing, the joy of gliding over the water with the wind. Backlight creates the magical atmosphere of this photo, playing a spot light on the bellying sail and bouncing off the fine curling of the waves. The rather low bank on the horizon illustrates the photographer's superb eye for composition. It connects two very dissimilar picture zones very dramatically and at the same time accentuates the dividing line between light and shadow. The full sun-soaked sail set against shadowy mountain slopes reminds of an evening in spring. Tech. data: 135-mm Elmarit-R, 1/500 sec., f. 5.6, Agfachrome 50 S.

84 "Rider"

Louis Dickers, Belgium

This picture is the result of technical know-how. Not only was the camera panned along with the subject but also a delicate black-and-white copy was superimposed on the original shot. What a pity, some might say, yet one can understand the photographer's wish to accentuate form by adding light edges to the contours. This was done so expertly that one has to look twice in order to recognize

the trick. Also note the romantic mood of the picture, the soft brown tones. The rider is sharply contrasted against the blurred similarly hued background. Tech. data: 135-mm lens, 1/15 sec., f. 8, Kodachrome 64.

85 "Giant Slalom"

Gerhard Bluhm, Austria

Subjects like this one are frequent, yet rarely so perfect. Gerhard Bluhm photographed the Austrian Worldcup-winner Monika Kaserer during a giant slalom in Saalbach/Austria. Bluhm, an engraver from Salzburg, simply outdid all the professional sports photographers in this contest. He received 1st prize in the snapshot group. He chose a position from which he could take the skier emerging from a hollow against the dark background of trees. This one is the best of a whole series he shot with a 400-mm Telyt lens on his Leica, at 1/500 sec., f. 5.6 on Agfacolor CT 18.

86 "Sven Ake Lundbäck"

Svenerik Lindman, Sweden

The photographer writes that he postioned himself with his camera at the summit of a slope in order to shoot the cross-country contestants in a 50-kilometre event against a magnificent background of hills and lakes. In addition, he wanted to take his famous compatriot Sven Ake Lundbäck from the front. He intentionally worked with backlight because it effectively lights up the back of the skier's head and arms. "I hope that the backlight in this picture particularly helps to illustrate what a marvellous sport cross-country skiing is." Tech. data: 135-mm Elmarit-R 1:2.8 on a Leicaflex SL, 1/250 sec., f. 5.6, Kodachrome 64.

87 "Finish"

Edgar Ollmann, Austria

E. Ollmann took this canoe in impressionist style. In spite of a relatively long shutter speed (1/8 sec. on Kodachrome 25) this picture is slightly underexposed. The unfavourable light conditions forced him to open his 180-mm Elmarit lens up to f. 2.8 and the picture shows the actual atmosphere of the moment of exposure. Ollmann took a whole series of photos and took care to catch the canoe at

a certain phase. Only two of 15 exposures turned out the way had planned them, and the m interesting one of the two is reproduc on this page.

88 "Water Skiing"

Otmar Riedlhuber, Austria

While the sports photographer usua favours the flying phase in ordin ski jumping, in water skiing he pref the often comical landing manoeuve Riedlhuber took this one from shore of the Attersee at the mom when the skier re-alighted on water. The difficult part of this ty of photography is that the motif c has in mind always lands in a differ part of the lake. Only utter cc centration and quick reaction will le to results. The best way to approa is to follow the water skier with camera from the moment when takes off. Panning, adjusting the ap ture and pressing the shutter at exact moment take some practi Riedlhuber used a 560-mm Tely lens on his Leicaflex SL and set it 1/500 sec. at f. 8 on Agfacolor CT

89 "The last Round"

Emilie Stark, Germany

E. Stark calls her entry the result sheer luck. One has to agree w her, for it does take luck to get su a dramatic scene at such close ran But without the technical know-h and especially her daring way handling subject and camera t picture would not be what it is. C of countless bullfight pictures—a there must be thousands—we cc sider this to be one of the few a cannot easily forget. And it is effective example of how an ima native photographer can find ne ways of treating even the most clich motif. Tech. data: 135-mm Elma 1:2.8 lens, 1/60 sec., f. 5.6, Ag color CT 18.

90 "Spurting to the Fore"

Max Itin, Switzerland

Blurring has enlivened colour pho graphy in general and sports pho graphy in particular. Max Itin's ph proves that even the rules which down that a point of focus is nee to hold a picture together are debata when looking at his entry. The he

the first cyclist is anything but in
us. The reason is that he had set
camera at 1/8 sec., f. 22 (Agfa-
or CT 18). An overcrowded back-
und (a forest) was converted into
uiet, light path by using a 50-mm
nmicron 1:2.8 lens. The road is
ured as a dark streak between fore
background and forms the track for
cyclists trying to gain the lead.
light reflections around the wheels
cate speed. The red and yellow cap
shirt are effective colour spots in
almost monochrome picture.

91 "November Hunt"

Horst Reichl, Germany

The hunting scene submitted by Horst
Reichl is especially effective because
of the blurring and the double contours
on horse and rider which make for
such an interesting colour scheme.
The bright colours in the foreground
and the dark ones in the background
blend into each other. This technique
creates an Impressionist atmosphere—
dark an sharply delineated subjects
would spoil the whole mood of this
picture. It transmits a romantic feeling

to the viewer. The photographer, who
discovered his subject at a hunt in
November, is a master of blurring
(after a lot of practice, as he says).
A speed of 1/15 sec. and following
the subject with his lens has produced
beautiful results for him many times.
Reichl's photo serves as another
example of how blurred photos do
not necessarily need a sharp point of
focus as long as the degree of blurring
is kept within limits. Tech. data:
135-mm Elmarit-R 1:2.8 lens, 1/15
sec., f. 5.6, Ektachrome 19 DIN.

tor's note:

e might say that demand controls
ply even in the realm of sports
tography. In no other area of
tography have so many amateurs
n able to convert their hobby into
rofession. Almost all of the big-
ne internationally renowned sports
tographers have started out as
ateur photographers. Initially it was
r love of sports which motivated
m to take photos, and later the
n instantaneous love of photo-
ohy. It motivated quite a few to say
odbye to promising careers and
ote their lives to photography,
ne what may. Nothing is a better
rantee of success than photo-
ohic performance. This is why even
owned sports photographers do not
sider it beneath them to parti-
ate in minor and major photo
tests. Publication of his photo on
rge scale—maybe world-wide—
y mean another commission for him
ven the beginning of a stupendous
eer; it has happened time and again.
er Leser, for example, the well-

known sports photographer, owes his
subsequent career to the success he
had as an amateur photographer in
contests and exhibitions. The sports
editor of a large daily hired him on the
spot upon seeing the brilliant photos
he had taken at a Gymnastrada and
submitted to a contest. He still holds
this job as a sports photographer and
meanwhile has become one of the
most distinguished representatives in
this field.
Looking at the pictures reproduced
here proves that there is a lot of young
talent around. Most of the entries
were submitted by young amateurs
who are all equipped to follow in the
footsteps of their great predecessors.
The only other qualities needed are
organisational talent and the ability
to assert oneself, for this is what
the sports photographer needs most
of. He has to be able to cover a wide
range of subjects and competition
is rough. This is why in spite of a
tremendous demand for sports photo-
graphers the way to the top still leads
via the tough assignments in the big

cities and sports arenas. And maybe
the amateur photographer has more
fun in his local stadium than his
famous colleagues behind the goal-
posts of a major-league football
match.
Photographing at small-town events
where the budding sports photo-
grapher can experiment with various
techniques without being hustled by
officials and crowds can have defini-
tive advantages, such as asking for
an extra run, for example. It is an ideal
training ground for those wishing to
learn the technique of panning, where
one can take dozens of shots (on
inexpensive film). One has to move
around a lot until one finds the most
advantageous shooting position for
the start or the finish. Nor does one
have to start out with a 400-mm lens
but can do with a normal 135-mm
telephoto lens. And last but not least
the amateur can choose his particular
sport, since he does not have to cover
an event for any newspaper. He can
take what he likes as long as nobody
behind him hustles and bothers him.

Photographic Experiments from Kitsch to Art

It isn't the aim of this publication and the following reproductions of works in experimental photography to give a definitive reply to the age-old problem of the artistic merit of photography. Everyone must decide for himself what art is. The definitions of scholars and art historians on this point seem little better than guidelines for the consumer. Nor are the speculative prices sometimes paid nowadays for photographs as works of art an indication of the true value of a picture. And so the reader must make do with my personal opinion that art is to be found in a picture which is not only a masterly composition of form and colour (since craftsmanship is a prerequesite for every work of art), but which is more than a mere visual impression. Art of this kind must stir and move us, must transmit a thought, an idea, even a message from the artist; it does not arise directly from the subject of the photo but is an interpretation of the subject. And of course a lot of what is offered on the market as art does not deserve that name.

Contemporary photography, especially colour photography with its immense range of technical darkroom possibilities, enables the creative photographer interested in free design to produce virtually everything imaginable with a camera. Exposure technique, montage, collage, the endless possibilities of chemical manipulation are the tools enabling the photographer—like the painter and the graphic artist—to be creative, right down to the complete abstraction of a subject. However, if photographers do not produce real art in spite of the highly sophisticated technical means available to them then there may be several valid reasons. The main cause is ignorance of all the possibilities open to them, and lack of skill in handling all the materials and equipment. Complete mastery over the materials is only the first step towards translating a creative idea into a picture. It is comparatively simple and possible even for the layman to make a photographic image, since the camera does most of the work, and yet it is obviously difficult to transmit an artistic vision through the camera. The end results is what counts. It may be art and considered as such or it may be kitsch, an abuse of photography.

This extremely abstract photo of a pair of wings was deliberately selected as the first in this series (see opposite). It was sent in by a young American physicist along with a whole series of similar subjects. Although one might think otherwise, they were produced by purely photographic means (in so far as photochemical processes are included in this concept). Nothing in this example recalls the bird's wings which were initially photographed. The image, transformed into a thought-provoking symbol, challenges individual interpretation. What is dominant: the aesthetic representation or the idea it attemps to transmit? Is it inferior because of its photographic origin? How should we assess its close relationship to the subject that was photographed realistically in the first place? Who is to prevent us from considering this proven "blood relationship" as a not particularly attractive aspect of this composition? Question upon question. Kitsch or art?—that's up to you to decide.

Contents

The pages are not numbered. The numbers under the pictures refer to the commentaries and the numbers in the index of photographers.

Text and layout: Hugo Schöttle

Published in the United States of America in 1977 by:

RIZZOLI INTERNATIONAL PUBLICATIONS, INC.
712 Fifth Avenue/New York 10019

Library of Congress Catalog Card Number: 76-27019
ISBN: 0-8478-0065-2
Printed by Offset in West Germany

Cover picture: Achim Balon, Stuttgart

INTERNATIONAL PHOTOGRAPHY – THE CRITICS' CHOICE

Commentary
by Hugo Schöttle

RIZZOL
NEW YORK

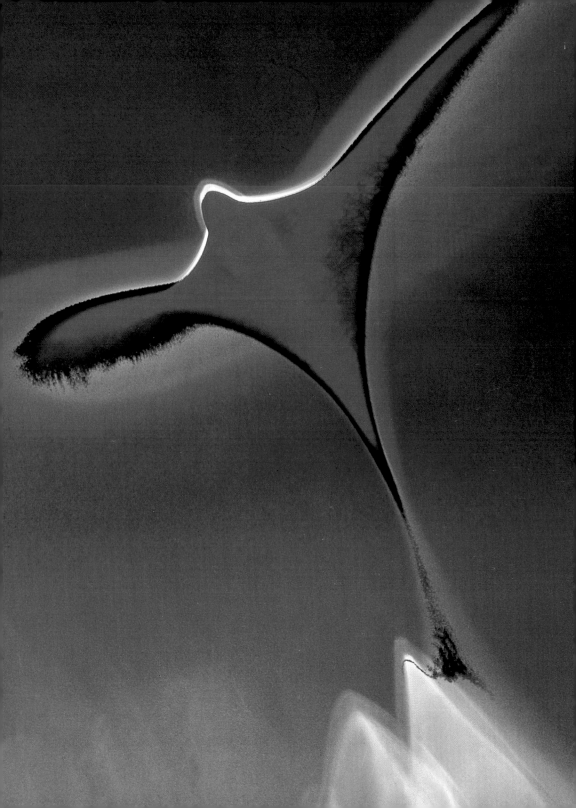

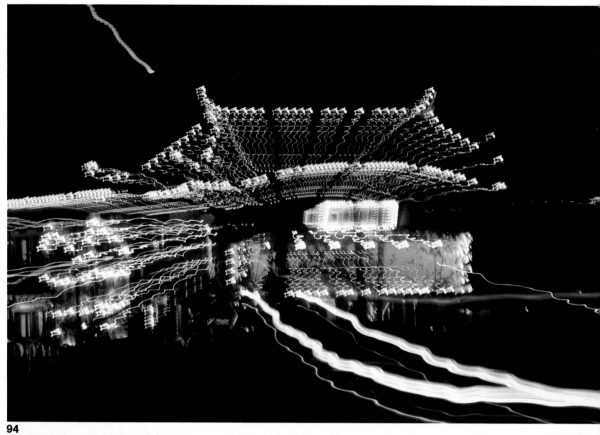

94

95

96

97
98

"Transparent Wings"
Martin A. Folb, USA

s picture was produced by purely otographic means. The striking wing icture was alienated with the use light and special darkroom tech- ues. Dr. Folb used a Leica with oflex and bellows unit and a lens n the old Hektor 135 mm with a nbination of additional close-up ses (a total of 23 dioptres). The gs were processed with light from ous lamps and the central area of the ture with a laser beam. This expo- e, copied several times on a litho- phic film, rendered several masks, of which was then superimposed the original transparency. Data: 000 sec., f. 4.5, Kodachrome 64.

"Mexican Fiesta"
ul Lutzelschwab, France

photographer has exaggerated rring to express movement to such extent in this picture that the ult borders on experimental photo- phy. The dancers were taken during olklore event in a theatre. Normal ge lighting and several spot lights ved as the light source, and the rring is due soley to the movement the dancers, so that this picture is rue rendition of the actual dance vements during the exposure time 15 sec., f. 11). This colour ecstasy ure to meet with a variety of reactions n the readers. In any case, it is a ing experiment which produced ynamic picture. He used a 135-mm s on his Leica.

94 "Chains of Light"
Chun-Biu Lam, Hong Kong

Street lights on buildings and head- lights on cars speeding through the night have traced this picture. The photographer did not submit exact data, but it seems that this is the photo of an illuminated pagoda in the streets of Hong Kong. The effectiveness of this picture is due mainly to move- ment—both of the cars and the lens. Since there are no stationary lights to be detected, one can assume that the photographer used a tripod while altering the focal length of his zoom lens over a span of 4 seconds. This would explain the jerkiness of the streaks of light in this photo which is intriguing for several reasons: not only does it have a certain exotic appeal but it also stimulates the reader into trying to identify it. Data: 80—200-mm Vario Elmarit 1:4.5 on a Leicaflex SL, 4 sec., f. 8, Ektachrome High Speed Type B.

95 "Belfry"
Ewald Stark, Germany

The belfry of a small chapel was taken on the island of Crete. The photographer sandwiched his motif, which is a relatively simple process: he superimposed two identical exposures (one back to front and set slightly to one side) in a slide frame. Then he copied this graphic picture on a colour reversal film in order to intensify the contrast and he obtained deeper blue and purer white tones. This is what he was after, because as

he says this technique accentuates the typical Mediterranean character better. We leave it up to you to judge whether or not he succeeded. Data: 400-mm lens on a Leicaflex SL, 1/125 sec., f. 8, Agfacolor CT 18.

96 "Night Impressions"
Herbert W. Weiß, Germany

H. Weiss is lab director of "Foto- studio 13" in Stuttgart and an enthu- siastic experimental photographer who works a lot with darkroom techniques. Weiß used black and white paper on which any given line, area or colour shade can can be filtered out by special copying techniques. This equal- density picture thus obtained can be coloured in any chosen tone. The colours are sandwiched and then copied. Herbert Weiß used Ektachrome High Speed (Type B). Striking in this composition is the utter simplicity of design and colour, the reduction of his motif to a single line.

97 "Infrared Iceland"
Julius Behnke, Germany

One of the simplest techniques for the amateur photographer to "alienate" colour is to use an infrared film. Originally developed for military pur- poses it now serves as one of the most popular films to play around with and produce trick exposures. Sensitized for infrared, red and green it changes colour after printing so that yellow turns into blue, green into blue and red into green. One can carry this further by using additional

colour filters which alter the colours even more. Data: Elmarit-R 1:2.8/150-mm on a Leicaflex SL, 1/125 sec., f. 5.6, Ektachrome Infrared (19 DIN).

98 "Blue Cathedral"
Blaine Schultz, USA

B. Schultz, a 20-year-old student from Washington, had just bought himself a new 16-mm Elmarit-R lens and had gone to the country to try it out. Since he loved experimenting he had loaded his camera with an infrared film and occasionally added a colour filter (yellow and orange) for additional alienation. He wondered what would happen if he used a blue filter (density 80) and tried it on a burned-out barn which fascinated him because of the bizarre colouring on the charred boards and planks. He mounted a fisheye lens and a blue filter and was delighted by the beautiful graphic picture in his viewfinder. Yet something was still missing, so he asked a friend to stand in the doorway; his silhouette stands out against the light background. Data: 1/1000 sec., f. 16, Ektachrome Infrared (19 DIN).

99 "Composition in Blue"
Mark Markefelt, Sweden

This photo shows an original view of the monument which Finland erected for the great composer Jean Sibe[l] Mark Markefelt crawled under pipe construction and photograp[h] with a wide-angle lens against sky resulting in a rather abst[ract] composition which owes its dynam[ic] to the mysterious circles, the l[ight] which plays on the outer surface these stainless steel pipes. A pass[er] by would see the original near Hels[inki] as a rather simple abstraction of organ, and of course nobody w[ho] knows the original would be able recognize it in this picture. It ra[ther] looks like a piece of modern art. D[ata:] 1/60 sec., f. 8, Kodachrome 25.

Editor's Note:

The fact that only eight pages of pictures are devoted to experimental photography in this book shows that this branch of creative photography does not receive the attention it deserves. And yet it is precisely in this field that the photographer can develop his imagination and artistic craftmanship. There are several relatively simple tricks in colour photography which do not even require a well-equipped darkroom. They include the use of colour filters, zoom and trick lenses, colour Ektachrome Infrared film and the now so popular sandwich technique. The latter is simply the superimposition of two suitable slides in one frame. However, many of the competition entries made in this way prove that this technique often results in producing kitsch. Moreover the reproduction of inferior trick photography in periodicals and books has not exactly promoted experimental photography. No insuperable technical difficulties prevent the photographer from venturing into this field of free photographic design. Naturally the darkroom offers a wide range of further possibilities such as separation of colour tones and unlimited range of colours, made possible since the development of the equaldensity film Agfa-contour-Professional.

To go back to exposure techniques, picture 95 illustrates a very simple sandwich montage. It is noteworthy because the photographer has produced a picture with subtle colouring — a monochrome in blue. The montage of one and the same picture superimposed presents no difficulties either. Another equally easy procedure is shown in picture 53. A landscape was made all the more interesting by superimposing two variations of the same subject. In both cases, for all their simplicity, every detail was carefully thought out in advance. Exact planning is necessary, especially when two complete different subjects are to be sandwiched together. So[me] photographers sketch their sandw[ich] pictures on paper beforehand. [The] exposure must be carefully meas[ured] and calculated as slides intended a sandwich picture have to be expo[sed] differently from a "normal" slide. the density of the two slides combined, each must be slig[htly] overexposed. Colour infrared should also be used carefully chance results rarely lead to g[ood] pictures. It is important to know h[ow] the natural colours come out on film and which filter is needed to a[lter] the natural-unnatural colour ra[nge] yet again. The manufacturers (Koc[h,] Stuttgart) issue information she[ets] which save the consumer a lot expensive experimenting. Colour in[fra]red film is often used in nude pho[to]graphy as this renders superior s[kin] colour. Colour infrared landsca[pe] photography is a vast field requires careful use of filters as [here] a very thin line divides art from kits[ch]

ndex